The Collected Poems of Mary Ellen Solt

The
Collected
Poems
of
Mary
Ellen
Solt

Edited
by
Susan
Solt

Primary
Information

Contents

Words and Spaces

The Peoplemover 1968:
A Demonstration Poem

CIVIL RIGHTS/JAIL
For MARTIN LUTHER KING/
 RESURRECTION CITY
VIET NAM/JET PEACE
The USnaApalm/EQUALS THE
 QUESTION
PEACE TALKS/FIVE PAST MIDNIGHT
HUBERT HORATIO HUMPHREY/
 VOTER'S "X"
NIXON/VOTER'S "X"
KENNEDY/THE LINCOLN MEMORIAL
THE AMERICAN ENVIRONMENT/
 DOLLARS

Marriage: A Code Poem

I Pairings, II Conjugations
III Family, IV Home
V Relationships, VI Moods
VII Dimensions, VIII Conclusions

Letter to the Editor (later poems)

Letter to the Editor
Letters from Amelia
Fellow Traveler
Pittsburgh
Kairos
Searching for the Grave of
 the Equilibrists
In the Catskills (for Susie)

Afterword by Susan Solt
Calligraphic Flowers (1963–65)
Notes
Bibliography
Biographies

Foreword

I met Mary Ellen Solt in 1969 when I was invited to read at Indiana University. I was in my midtwenties, and my concrete/minimalist poetry had caused a storm in literary circles that caught me, naively I should say, by surprise. The invitation to read at a university was both the first and the last that I'd receive for some time, and I'm sure it came due to Mary Ellen's sponsorship. Along with Emmett Williams, she was among the best known of the American concrete poets, her *Flowers in Concrete* series, represented in facsimile in this book, a recognized masterpiece of the oeuvre. She and her husband, Professor Leo Solt, a charming youthful couple, were my hosts, and after the reading I spent the night in their home.

I learned from this book that more or less contemporaneously we had traveled similar paths in our work. "The problem of modern literature," Alfred North Whitehead advised, "is to make the words embody what they indicate." Mary Ellen's mentor, William Carlos Williams, who played a similar role in Denise Levertov's development, decreed: "No ideas but in things." How to accomplish that, exactly? Dr. Williams dropped hints all over his work, famously in his red wheelbarrow poem, in which each two-line stanza ends with a single word pending over the next stanza:

so much depends
upon

—the shape itself like a little wheelbarrow.

In the third section of this book I found Mary Ellen's adventures in this arena, shrinking and stretching words and stanzas in all sorts of ways—vivid, intimate inventions I'd never seen before:

whirl wind
whirl pool
whirl girl

One wonders how such a definitive poet's collected work has been so long in coming and, alas, posthumously. But then it's only in recent years that concrete poetry, with its centuries-long international lineage, has begun to be recognized as part of our literary-artistic canon. Better late than never, here is the gift of this generous, abiding, and I find it impossible not to say, *happy* poet—a cause for gratitude and celebration.

Aram Saroyan

What
the
Girl
Might
Have
Said

WITH CHILD

if in my condition
i grow round as the
earth grew round

blunt as the plum shapes
to the sun's full
outline

if i am the sky where a
wing beats
the sea where a

fish swims
in my forever
why is it i

want to vomit
the thing

SEASCAPE

a slick rock
an abalone

 jade waves slap
 and recede

 rubbed to a
 glitter sunwards

under
where a shell's
 stuck
 TIME

 drifts
 and stares

a fish slips
silvery

 through its
 element
 the rock glistens

washed

 by ambi-
 valent waves

ILSE

this
otherwise you'd
just
vanish

a lump
rose
on your
neck

you hid it
under a
silk
scarf

your left
arm
grew
useless—it was

stupor
or pain—
the morphine
failed

you wanted to
jump
through the
sounds

from the cafe
seven
floors
down

one night
drugged
you slept
for the last

time
while I
sleeping also
dreamed

I dreamed you
well
again
your skin

glowed
but your
attitude
was transient

I never
saw you
dead
your mother

said Ilse
didn't like to be
seen
in private

postures
and herself
wouldn't look
at the dead—

nowhere
you existed
as I
knew you

WAS IT KINDER

ILSE
for a whole year
we watched you
die
lying there while we
lied to you

JUPITER

 the
cat who
sleeps and for-
gets that
outside it's
ten be-
low
asks me to
open the
door, re-
treats from the
icy
blast then
bites my
ankle
savagely for
reasons
clearer to
me no
doubt than to
him

YOU HAVE FAILED but

do not say love
disappoints you
know
that love is
grace
 grace is
love
given in trust
freely
 trust fails
 .

THE WHITE FLOWER

a girl
 a piano
 two counterpointing themes
of bach

 and that night
 early

the kind custodian:

 go over to the greenhouse
 the night-blooming cereus is
 opening its petals

the flower was
 soft
 moist

like the gardenia that danced on my shoulder at
 parties

 an overpowering
fragrance

 since then in
 out

of my mind
 a white
 flower

sometimes it congeals as
 sacré

 coeur

or drifts
 a severed

 hand

tonight
 in my mind

 a trembling incandescenoo

like sirius
 flickering

 in the pollen of the
sky

 in the close dark
 a white

rose
 litters
 the night

wind

the close light

 from my kitchen

window

falls on a border of

 marigolds

 i laid their seeds

in a furrow

 and covered them with

 earth but they look

blurred

 like flowers under

 water

THE TATTOOED LADY

it must have been the idea
that crawled first across her
skin
but when tallow arms and
legs, breasts and
abdomen turned to
swirling blue rivers
(or are they snakes) how
terrified she must have been

the scar invisible
won't toughen
turn white
her head seems a thing
detached
dressed in suit, gloves and
service weight nylons
she could pass as
any lady

FOR WILLIAM CARLOS WILLIAMS

queen anne's lace

sways

 in the

wind

then holds

the summer

stillness

a child

white lace upon

lace

 almost to her

eyes

spreads her hand

to en-

compass the

flower

the picked weeds

fall

 in a

white

powder

 each

needle-tube

that has held

and fed

the minutest

subtraction of

flower

releases a

dry

seed

 except the

dark

flower

still soft

purple

at the

center

SATURATION POINT

love goes
that's bad e-
nough

Love comes
there's no such
joy

Love comes
and goes
while old love

bleeds still—
that's
too much!

Then surfeit
gets
its toll:

Flesh
starved back
to prescribed

size needs
exercise of
soul

to tone up
will
and sinew.

Duty and
Habit
are

stern
pitiless
coaches.

MEDITERRANEAN

on holiday from ever
 searching
 for the ex-
act
 word

 for the
phrase
 that erases
pages

 for the
sound re-
 moved
 that
closes
 the poem

 on holiday from
quotidian de-
 sire
 that finds its
objects
 less than was
 longed for
 expected

at first sight of the sea near
 sète
 we run to the presses of the
waves ejecting
 water sheets that
 vanish as we
watch
 littering the sand
 with
shells
 starfish
 a lone dead
seahorse

 to make the case of
 life
 inconsequential

 but to translate the
 scroll of the
 seahorse
 to choose among the
 synonyms of
 shell
 to chart the astronomy of the
 starfish
 boggles the mind
 utterly

BIRD

in the eaves
you who keep searching
for seeds

the sweet seeds have drifted
away
the wet leaves
chill you

brown bird in the
eaves

look! the
children are coming with
bread

first he rushed over to a
large chair
lifted its tail and
kissed the ass of the
cat sleeping

then we had lunch
"you eat like a pig"
my daughter said
"i love v-ape juice"
he replied

then they played house
"but i want it" "no
it's mine" she
cried he kicked the
cardboard walls down

"what shall we play now"
"i won't play with you
 you break my toys"
"why did you invite me then
 you're a coo-coo head"

to keep the cold out
 i'll get
one more
 blanket
two daughters
 petals
closed
 to the night
before the season
 of
tough
seeds
 how do i say to them
do this
 and do this

 and do this

TOUCH

it was touch of you

touch of you

touch and go

time

changes it

touch into feeling

go into stay

it changes

time

apples on the lawn

grapes resisting

gravity

it is that

you

touch me

touch me

touch me

WHAT THE GIRL MIGHT HAVE SAID

 it was so iri-
 descent
 waking there
 the
 sunlight in my hair
 the jeweled
 earth

 then i
 noticed that you'd
 left
 left me standing on a
 stair
 transfigured
 strangely
 bereft

 i couldn't throw my flowers down the
 stairs
 still fragrant
 alive
 they
 fell
 anyway

when the numbness
 reached my
arms
wistfully i looked at them
 until the
tears froze:

 all that loveliness
 of earth . . .

la figlia che piange

 how did you know
you said there was resentment
 in my
 eyes

beautiful words
 but do they pardon
failure
couched in the cells of re-
pentence

 the body
 useless
abused
 by the discovery of
soul
 the
holy, faithless
soul
 that if it has a
choice
 can kneel
and go
 or stay de-
filed
 or unused

TOTENTANZ

the old
cat

a curled
leaf

he teases
it

brittle
in-

tact on the
wax

pirou-
ettes

then curled
up

sleeps
sleeps

FLOWERS IN CONCRETE BY MARY ELLEN SOLT

FOR LEO

FLOWERS IN CONCRETE BY MARY ELLEN SOLT
DESIGNED AND PRINTED BY JOHN DEARSTYNE

DESIGN PROGRAM FINE ARTS DEPARTMENT INDIANA UNIVERSITY

We wish to thank the following periodicals for permission to reprint the poems: Poetry for "Marigolds" and "Dogwood: Three Movements;" Poor, Old, Tired, Horse (Scotland) for "White Rose;" Labris (Belgium) for "Geranium," "Lilac," "Wild Crab," "Lobelia," "Zinnia," and "Forsythia."

Traditionally the typographer has given visual form and order to words, thus serving both the writer and the reader. His problem is mainly one of clarity of communication, literary meaning, and hopefully aesthetic contribution to the art of the printed page.

When publishing concrete poetry, it is sometimes difficult to draw a line between the contributions, as well as final responsibilities, of the poet and the typographer. The literary and visual meaning of concrete poetry as conceived by the poet and interpreted by the typographer is somewhat analogous to a stage performance of a play.

This volume includes both typographic interpretations and an original calligraphic poem, "Dogwood: Three Movements," selected by the editor on purely visual merits.

George Sadek

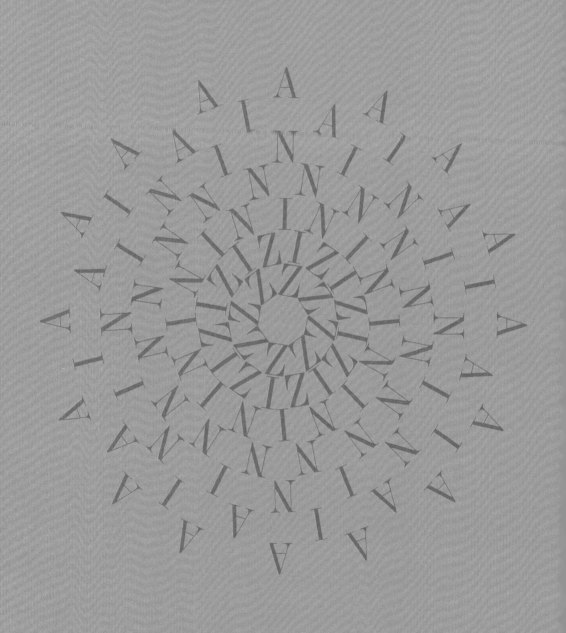

SUMMER

MEASURES SUMMER TIMES

SILENCE GODS EXIT SUMMER

UMBELLAR RESOUNDS

RED INTERPRETS NO ONE A CAPELLA ANSWERS

SEEN EACH

God's	*summer*
Exit	*times*
Resounds	*summer*
A capella	*answers*
No one	*each*
Interprets	*seen*
Umbellar	*red*
Measures	*silence*

Lovers
Of
Blue
Elide
Loves
Instant
Annulment

Magnificat
Aurioles
Rousing
Insensate
Grief
Oh
Long
Death
Suddenly

Wind, Intrudes, Lifting Day,
Cantabile, cantabile,

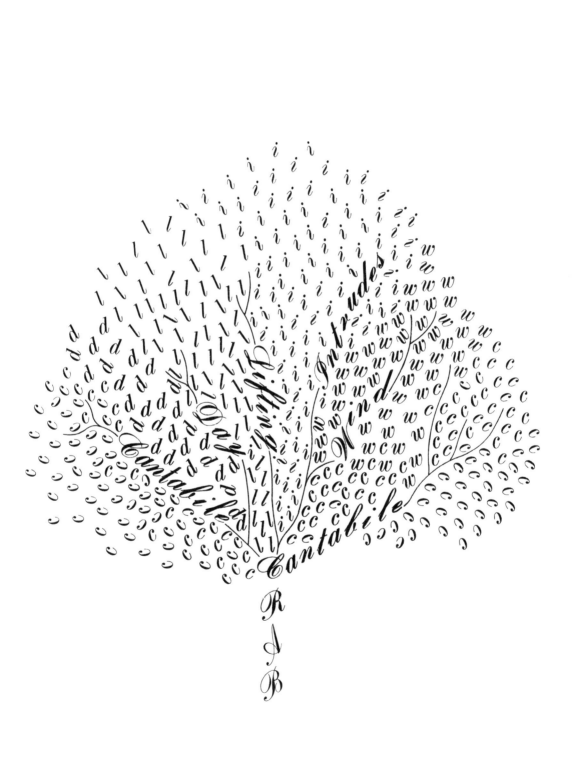

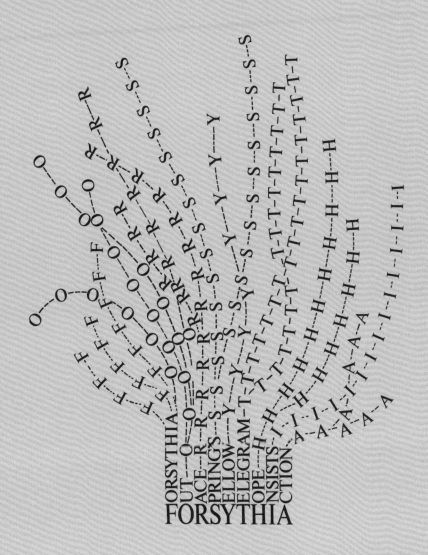

FORSYTHIA

DOGWOOD: THREE MOVEMENTS
For Robert F. Heimburger, M.D.

According to legend the dogwood once grew as tall and strong as the oak. So to its great disgrace it was chosen as the tree most suitable for the Cross. Christ, though, pitied the tree in its shame and sorrow and performed the miracle of the dogwood. Henceforth, he said, it would grow short and crooked so that never again could it be used to such igno- minious purpose. Each spring it would bear white flowers of four petals in the shape of the Cross with the crown of thorns at the center. And the tip of each petal would be not- ched and stained in memory of the nails and blood.

"Dogwood: Three Movements" attempts to relate the visual properties of the word to the shape of the flower as the symbol of suffering and its redemptive power, and to the laws of its growth in ascending planes of white.

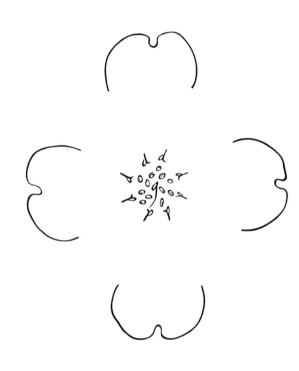

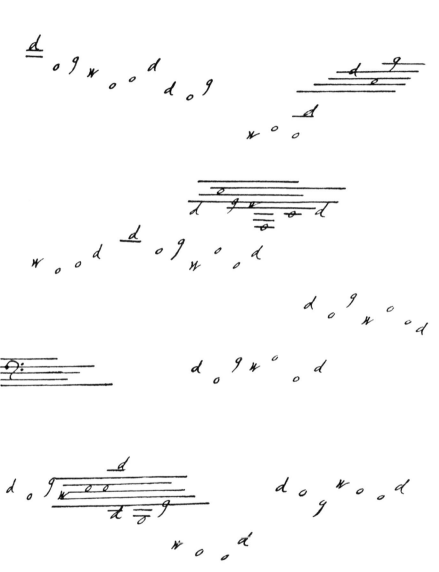

Words
and
Spaces

"Moonshot Sonnet" consists of the crosshatched grids of a Réseau plate as fitted to the array of cameras mounted on the *Ranger 7* space probe. The photographs—the first close views of the lunar surface—were published in the *New York Times* on August 1, 1964. Solt notes "that by simply copying these symbols I could make a visual sonnet—there were fourteen 'lines' with five 'accents.' We have not been able to address the moon in a sonnet successfully since the Renais sance. Admitting its new scientific content made it possible to do so again. The moon is a different object today." Drawing by Timothy Mayer to Solt's specifications.

"ZIGZAG" was originally printed by the author on Japanese rice paper using wood type. Solt notes that "the form of the poem is 'orthodox' concrete, but the use of wood-type capitals departs from the customary machine printing and lower-case letter. I am willing to say that the poem had to be written in order to provide an excuse to use this 'Z'—an initial for the word, as Mallarmé might say."

ZZZZZZZZZZZZZZZZZZZZZZZZZZZZZZZZZ
ZZZZZZZ Z ZZZZZG Z ZZZZZ
ZZZZZZ Z ZZZZAG Z ZZZZZZ
ZZZZZ Z ZZZZAG Z ZZZZZZZ
ZZZZ Z ZZGZAG Z ZZZZZZZZ
ZZZ Z ZIGZAG Z ZZZZZZZZZ
ZZZZ Z ZZZZZZ Z ZZZZZZZZ
ZZZZZ Z ZIZZZZ Z ZZZZZZZ
ZZZZZZ Z ZIGZZZ Z ZZZZZZ
ZZZZZZZ Z ZIGZZZ Z ZZZZZ
ZZZZZZZZ Z ZIGZAZ Z ZZZZ
ZZZZZZZZZ Z ZIGZAG Z ZZZ
ZZZZZZZZ Z ZZZZZZ Z ZZZZ
ZZZZZZZ Z ZZZZZG Z ZZZZZ
ZZZZZZ Z ZZZZAG Z ZZZZZZ
ZZZZZ Z ZZZZAG Z ZZZZZZZ
ZZZZ Z ZZGZAG Z ZZZZZZZZ
ZZZ Z ZIGZAG Z ZZZZZZZZZ
ZZZZ Z ZZZZZZ Z ZZZZZZZZ
ZZZZZ Z ZIZZZZ Z ZZZZZZZ
ZZZZZZ Z ZIGZZZ Z ZZZZZZ
ZZZZZZZ Z ZIGZZZ Z ZZZZZ
ZZZZZZZZ Z ZIGZAZ Z ZZZZ
ZZZZZZZZZ Z ZIGZAG Z ZZZ
ZZZZZZZZ Z ZZZZZZ Z ZZZZ
ZZZZZZZ Z ZZZZZG Z ZZZZZ
ZZZZZZ Z ZZZZAG Z ZZZZZZ
ZZZZZ Z ZZZZAG Z ZZZZZZZ
ZZZZ Z ZZGZAG Z ZZZZZZZZ
ZZZ Z ZIGZAG Z ZZZZZZZZZ
ZZZZZZZZZZZZZZZZZZZZZZZZZZZZZZZZZ

so swift the

stone skips

(why did you not move your
 ()
eyes)

then sinks
 (())
with no

sound
 ((()))

 (((())))

 ((((()))))

 (((((())))))

 (((((((()))))))

glow
shadow

glow
shadow

glow
glow

shadow

daughters and

poppies and

poppies and

daughters and

night

in daughters and

poppies and

```
                                        l e a f

                                        f a l l

                                        f a l l

                                        l e a f

                                        f a l l

                                        i n g
```

LOOK

 a l e a f

 t h e l e a f

 f a l l s

 f a l l s

 a n y w a y

road S

track S

river S

dream S

whirl wind
whirl pool
whirl girl

--fly

butter

--fly

butter

--fly

butter

--fly

gold pin for gertrude stein

Water's

Absolute

Tear

Eradicates

Return

Falls

Agitato

Lentando

Lentissimo

S now
N ights
O rphrey
W orks
F ilaments of
L ight
A ir
K nots
E scape
S olidity

rainrainrainrainrainrainrainrainrainrainrain
rainrainrainrainrainrainrainrainrainrainrain
rainrainrainrainrainrainrainrainrainrainrain
rainrainrainrainrainrainrainrainrainrainrain
rainrainrainrainrainrainrainrainrainrainrain
rainrainrainrainrainrainrainrainrainrainrain
rainrainrainrainrainrainrainrainrainrainrain
rainrainrainrainrainrainrainrainrainrainrain
rainrainrainrainrainrainrainrainrainrainrain
rainrainrainrainrainrainrainrainrainrainrain
rainrainrainrainrainrainrainrainrainrainrain
rainrainrainrainrainrainrainrainrainrainrain
rainrainrainrainrainrainrainrainrainrainrain
rainrainrainrainrainrainrainrainrainrainrain
rainrainrainrainrainrainrainrainrainrainrain
rainrainrainrainrainrainrainrainrainrainrain
rainrainrainrainrainrainrainrainrainrainrain
rainrainrainrainrainrainrainrainrainrainrain
rainrainrainrainrainrainrainrainrainrainrain
rainrainrainrainrainrainrainrainrainrainrain
rainrainrainrainrainrainrainrainrainrainrain
rainrainrainrainrainrainrainrainrainrainrain
rainrainrainrainrainrainrainrainrainrainrain
rainrainrainrainrainrainrainrainrainrainrain
rainrainrainrainrainrainrainrainrainrainrain
rainrainrainrainrainrainrainrainrainrainrain
rainrainrainrainrainrainrainrainrainrainrain
rainrainrainrainrainrainrainrainrainrainrain
rainrainrainrainrainrainrainrainrainrainrain
rainrainrainrainrainrainrainrainrainrainrain
rainrainrainrainrainrainrainrainrainrainrain
rainrainrainrainrainrainrainrainrainrainrain
rainrainrainrainrainrainrainrainrainrainrain
rainrainrainrainrainrainrainrainrainrainrain
rainrainrainrainrainrainrainrainrainrainrain
rainrainrainrainrainrainrainrainrainrainrain
rainrainrainrainrainrainrainrainrainrainrain
rainrainrainrainrainrainrainrainrainrainrain

s k y

 ra in ra i n rain
 ra in ra in ra i n rain rain
 ra in ra in rain ra i n rC L O U D in
 rain rain C L O U D in rain rain ra i n rain
 rain rain ra C L O U D rain rain
 rain rain ra i n rain rain ra i n rain
 rain rain r C LO U D in rain rain ra i n rain
 rain rain rain ra in
 rain rain ra i n ra in

 ra i n
 ra i n ra i n
 rain

 a

 i

 r

 n

raindownraindownraindown r a i n d o w n r a i n b o w
raindownraindownraindown r a i n d o w n r a i n b o w
raindownraindownraindown r a i n d o w n r a i n b o w
raindownraindownraindown r a i n d o w n r a i n b o w
raindownraindownraindown r a i n d o w n r a i n b o w
raindownraindownraindown r a i n d o w n r a i n b o w
raindownraindownraindown r a i n d o w n r a i n b o w
raindownraindownraindown r a i n d o w n r a i n b o w
raindownraindownraindown r a i n d o w n r a i n b o w
raindownraindownraindown r a i n d o w n r a i n b o w
raindownraindownraindown r a i n d o w n r a i n b o w
raindownraindownraindown r a i n d o w n r a i n b o w
raindownraindownraindown r a i n d o w n r a i n b o w
raindownraindownraindown r a i n d o w n r a i n b o w
raindownraindownraindown r a i n d o w n r a i n b o w
raindownraindownraindown r a i n d o w n r a i n b o w
raindownraindownraindown r a i n d o w n r a i n b o w
raindownraindownraindown r a i n d o w n r a i n b o w
raindownraindownraindown r a i n d o w n r a i n b o w
raindownraindownraindown r a i n d o w n r a i n b o w
raindownraindownraindown r a i n d o w n r a i n b o w
raindownraindownraindown r a i n d o w n r a i n b o w
raindownraindownraindown r a i n d o w n r a i n b o w
raindownraindownraindown r a i n d o w n r a i n b o w
raindownraindownraindown r a i n d o w n r a i n b o w
raindownraindownraindown r a i n d o w n r a i n b o w
raindownraindownraindown r a i n d o w n r a i n b o w
raindownraindownraindown r a i n d o w n r a i n b o w
raindownraindownraindown r a i n d o w n r a i n b o w
raindownraindownraindown r a i n d o w n r a i n b o w
raindownraindownraindown r a i n d o w n r a i n b o w
raindownraindownraindown r a i n d o w n r a i n b o w
raindownraindownraindown r a i n d o w n r a i n b o w
raindownraindownraindown r a i n d o w n r a i n b o w
raindownraindownraindown r a i n d o w n r a i n b o w
raindownraindownraindown r a i n d o w n r a i n b o w
raindownraindownraindown r a i n d o w n r a i n b o w
raindownraindownraindown r a i n d o w n r a i n b o w
raindownraindownraindown r a i n d o w n r a i n b o w
raindownraindownraindown r a i n d o w n r a i n b o w
raindownraindownraindown r a i n d o w n r a i n b o w
raindownraindownraindown r a i n d o w n r a i n b o w

```
s     k     y

c  l  o  u  d

r     r     r

a     a     a

i     i     i

n     n     n

r a i n  d o w n
r a i n  d o w n
r a i n  d o w n

r     r     r

a     a     a

i     i     i

n     n     n

b     b     b

o     o     o

w     w     w
```

LOVE is a
noun

YOU is a
pronoun

LOVE is a par-
ticular word

YOU refers to a par-
ticular word :

LEO

LOVE is also a
verb

its object
YOU

```
LL      LL      YY      LL      LL      LL
LL      LL      YY      LL      LL      LL

OO      OO      OO      OO      OC      OO
OO      OO      OO      OO      OO      OO

NN      NN      UU      VV      NN      NN
NN      NN      UU      VV      NN      NN

GG      GG              EE      GG      GG
GG      GG              EE      GG      GG

II                              II      II
II                              II

NN                              NN
NN                              NN

GG                              GG
GG                              GG
```

```
B  P
E  O
G  E
I  M
N
N  W
I  I
N  T
G  H
   O
O  U
R  T

E
N
D
    S
  M E
    S
```

Mommy,

what does

L

I

F

E

spell ?

"Elegy for Three Astronauts," for Virgil Ivan "Gus" Grissom, Edward Higgins White II, and Roger Bruce Chaffee, who died by fire on January 27, 1967, in the Apollo 1 command module.

```
            w   w   w
            i   i   i
            d   d   d
a   s   t   r               n   a   u   t
a   s   t   r       O       n   a   u   t
a   s   t   r               n   a   u   t
            w   w   w
            i   i   i
            d   d   d
            o   o   o
            w   w   w
```

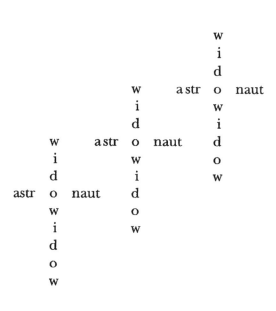

```
                              w
                              i
                              d
                w     astr    o    naut
                i                  w
                d                  i
  w     astr    o    naut          d
  i            w                   o
  d            i                   w
astr o naut   d
  w            o
  i            w
  d
  o
  w
```

 astronaut
 satronau
 starona
 straron
 staro
 stars
 starsa
 starsai
 starsail
 starsailo
 starsailor

 starsailor
 satrsailo
 astraio
 astrsao
 astrso
 astro
 astro
 astron
 astrona
 astronau
 astronaut

 astronaut
 satronau
 starona
 staron
 staro
 star
 stars
 starsa
 starsai
 starsail
 starsailo
 starsailor

(WATERGATE) TRANSCRIPT FOR UNCLE SAM

my fellow americans i have a statement

senator at this point in time we are

inoperative what did the president

and when tap tap tap poor

richard's all off-key biscayne so bebe it i

don't give a dime list thine enemies o

say can you flee from the grand's sure indict i

have privileges bring me my spear o

i hope to god he goes into government service

no stay away before the cox crows dean

knows gray's elegy by heart my advice is

let him hang they caught the creep at the scene

taping the watergate while they nixsinned

see how they twist slowly slowly in the wind

AFTER THE MOVIE

actually i don't care for it except
the supine way otherwise its a
gag oh i know it takes two to
tango but who wants to be brand-
ed by the likes of *this* brando--
especially with his blue jeans on--
anyway animals don't dance

moths do almost: they
flutter and flutter and go crazy
crashing into the light

nothing

added

everything

subtracted

divided by

one

multiplied times

ought

LAWALLAWALLAWALLAWALLAWALLAWALLAWALLAWALLAWALLAW
LAWALLAWALLAWALLAWALLAWALLAWALLAWALLAWALLAWALLAW
LAWALLAWALLAWALLAWALLAWALLAWALLAWALLAWALLAWALLAW

PRISONERPRISONERPRISONERPRISONERPRISONERPRISONERPRISON
PRISONERPRISONERPRISONERPRISONERPRISONERPRISONERPRISON
PRISONERPRISONERPRISONERPRISONERPRISONERPRISONERPRISON
PRISONERPRISONERPRISONERPRISONERPRISONERPRISONERPRISON

LAWALLAWALLAWALLAWALLAWALLAWALLAWALLAWALLAWALLAW
LAWALLAWALLAWALLAWALLAWALLAWALLAWALLAWALLAWALLAW
LAWALLAWALLAWALLAWALLAWALLAWALLAWALLAWALLAWALLAW
LAWALLAWALLAWALLAWALLAWALLAWALLAWALLAWALLAWALLAW

CONDEMNEDCONDEMNEDCONDEMNEDCONDEMNEDCONDEMNEDCON
CONDEMNEDCONDEMNEDCONDEMNEDCONDEMNEDCONDEMNEDCON
CONDEMNEDCONDEMNEDCONDEMNEDCONDEMNEDCONDEMNEDCON
CONDEMNEDCONDEMNEDCONDEMNEDCONDEMNEDCONDEMNEDCON

LAWALLAWALLAWALLAWALLAWALLAWALLAWALLAWALLAWALLAW
LAWALLAWALLAWALLAWALLAWALLAWALLAWALLAWALLAWALLAW
LAWALLAWALLAWALLAWALLAWALLAWALLAWALLAWALLAWALLAW
LAWALLAWALLAWALLAWALLAWALLAWALLAWALLAWALLAWALLAW
LAWALLAWALLAWALLAWALLAWALLAWALLAWALLAWALLAWALLAW
LAWALLAWALLAWALLAWALLAWALLAWALLAWALLAWALLAWALLAW
LAWALLAWALLAWALLAWALLAWALLAWALLAWALLAWALLAWALLAW
LAWALLAWALLAWALLAWALLAWALLAWALLAWALLAWALLAWALLAW
LAWALLAWALLAWALLAWALLAWALLAWALLAWALLAWALLAWALLAW
LAWALLAWALLAWALLAWALLAWALLAWALLAWALLAWALLAWALLAW
LAWALLAWALLAWALLAWALLAWALLAWALLAWALLAWALLAWALLAW
LAWALLAWALLAWALLAWALLAWALLAWALLAWALLAWALLAWALLAW

LONDON EXCHANGE

it's the absolute
isn't it

tisn't one thing
or t'other

it isn't
cold

that's it
isn't it

USA POEM

```
A
A    U
A    U S
A    U S A

        A    S U
        A    S U P
        A    S U P E
        A    S U P E R
        A    S U P E R B

        S U B U R B

                B L U R B
                B L U R

                P L U R
                P L U R I
                P L U R I B U
                P L U R I B U S

                        U S
                        U S    U
                        U S    U N
                        U S    U N U
                        U S    U N U M

        E    P L U R I B U S    U N U M

                P L U R I B U S    U N U
                L U R I B U S    U N
                U R I B U S    U
                R I B U S
                I B U
                B
```

THE CONCRETE MATCH
(For BILLIE JEAN KING vs. BOBBY RIGGS)

billy bobby billy bobby
 billy bobby billy
 bobby billy bobby billy

bobby billy bobby billy
 bobby billy bobby
 billy bobby billy bobby

billy bobby billy bobby
 billy bobby billy
 bobby billy bobby BILLIE

BE MY electroVALENgramcardioTINE

	diastolic		diastolic
systolic		systolic	
	systolic		systolic
diastolic		diastolic	
	diastolic		diastolic
systolic		systolic	
	systolic		systolic
diastolic		diastolic	
	diastolic		diastolic
systolic		systolic	
	systolic		systolic
diastolic		diastolic	
	diastolic		diastolic
systolic		systolic	
	systolic		systolic
diastolic		diastolic	
	diastolic		diastolic
systolic		systolic	
	systolic		systolic
diastolic		diastolic	
	diastolic		diastolic
systolic		systolic	
	systolic		systolic
diastolic		diastolic	
	diastolic		diastolic
systolic		systolic	
	systolic		systolic
diastolic		diastolic	
	diastolic		diastolic
systolic		systolic	
	systolic		systolic
	diastolic		diastolic

TERM POEM WITH COPY

two eyes two eyes
ibid. ibid.

one mouth one mouth
ibid. ibid.

one heart one heart
idid. idid.

two legs two legs
ibid. ibid.

one cock one snatch
ibid. ibid.

one body one body
ibid. ibid.

 one bed
 ibid.

ibid.
ibid.
ibid.
ibid.

RITES AMENDMENT

```
E  G  A  L  I  T  A  R  I  A  N
E  G  A  L  I  T  A  R  I  A  N
E  G  A  L  I  T  A  R  I  A  N
E  G  A  L  I  T  A  R  I  A  N
E  G  A  L  I  T  A  R  I  A  N
E  G  A  L  I  T  A  R  I  A  N
E  G  A  L  I  T  A  R  I  A  N
E  G  A  L  I  T  A  R  I  A  N
E  G  A  L  I  T  A  R  I  A  N
E  G  A  L  I  T  A  R  I  A  N
E  G  A  L  I  T  A  R  I  A  N
```

o ozonosphere ozonosphere ozonosphere ozonosphere ozonosphere o
o ozonosphere ozonosphere ozonosphere ozonosphere ozonosphere o
o ozonosphere ozonosphere ozonosphere ozonosphere ozonosphere o
o ozonosphere ozonosphere ozonosphere ozonosphere ozonosphere o
o ozonosphere ozonosphere ozonosphere ozonosphere ozonosphere o
o ozonosphere ozonosphere ozonosphere ozonosphere ozonosphere o
o ozonosphere ozonosphere ozonosphere ozonosphere ozonosphere o
o ozonosphere ozonosphere ozonosphere ozonosphere ozonosphere o
o ozonosphere ozonosphere ozonosphere ozonosphere ozonosphere o
o ozonosphere ozonosphere ozonosphere ozonosphere ozonosphere o
o ozonosphere ozonosphere ozonosphere ozonosphere ozonosphere o
o ozonosphere ozonosphere ozonosphere ozonosphere ozonosphere o
o ozonosphere ozonosphere ozonosphere ozonosphere ozonosphere o
o ozonosphere ozonosphere ozonosphere ozonosphere ozonosphere o
o atmosphere atmosphere atmosphere atmosphere atmosphere o
o atmosphere atmosphere atmosphere atmosphere atmosphere o
o atmosphere atmosphere atmosphere atmosphere atmosphere o
o atmosphere atmosphere atmosphere atmosphere atmosphere o
o atmosphere atmosphere atmosphere atmosphere atmosphere o
o atmosphere atmosphere atmosphere atmosphere atmosphere o
o atmosphere atmosphere atmosphere atmosphere atmosphere o
o atmosphere atmosphere atmosphere atmosphere atmosphere o
o atmosphere atmosphere atmosphere atmosphere atmosphere o
o atmosphere atmosphere atmosphere atmosphere atmosphere o
o atmosphere atmosphere atmosphere atmosphere atmosphere o
o atmosphere atmosphere atmosphere atmosphere atmosphere o
o atmosphere atmosphere atmosphere atmosphere atmosphere o
o aerosal aerosal aerosal aerosal aerosal o
o aerosal aerosal aerosal aerosal aerosal o
o aerosal aerosal aerosal aerosal aerosal o
o aerosal aerosal aerosal aerosal aerosal o
o aerosal aerosal aerosal aerosal aerosal o
o aerosal aerosal aerosal aerosal aerosal o
o aerosal aerosal aerosal aerosal aerosal o
o aerosal aerosal aerosal aerosal aerosal o
o aerosal aerosal aerosal aerosal aerosal o
o aerosal aerosal aerosal aerosal aerosal o
o aerosal aerosal aerosal aerosal aerosal o
o aerosal aerosal aerosal aerosal aerosal o
o aerosal aerosal aerosal aerosal aerosal o

A CLEAR AND PRESENT DANGER

t i'm e

t i'm e

t i'm e

t i'm e

t i'm e

t i'm e

t i'm e

t i'm e

t i'm e

t i'm e

t i'm e

```
deorr        deror        dorer        eordr
edorr        erdor        odrer        oerdr
doerr        dreor        droer        erodr
oderr        rdeor        rdoer        reodr
eodrr        edror        order        oredr
oedrr        redor        roder        roedr

      derro        drreo        dorre
      edrro        rdreo        odrre
      drero        rrdeo        drore
      rdero        errdo        rdore
      erdro        reodr        ordre
      redro        rredo        rodre

      drroe        eorrd
      rdroe        oerrd
      rrdoe        erord
      orrde        reord
      rorde        orerd
      rrode        roerd

            errod
            rerod
            rreod
            orred
            rored
            rroed
```

JET

country
city
town

country
JET
city
town

JET

country
city
JET
town

highway
stream
tree

country
city
town
JET

highway
JET
stream
tree

highway
stream
JET
tree

JET

highway
stream
tree
JET

airport
violet
earth

airport
JET
violet
earth

airport
violet
JET
earth

airport
violet
earth
JET

AM

BER

am

ber

weath

er

Oc

to

ber

fall

ing

AM

BER

Oc

to

ber

o

ver black

sha

dows

fall

ing

charades
charades

RUS

TLE

of

am

ber car

tog

raphy of

cob

webs the

world

turns

LONE

LY and

o

ver and

am

ber Oc

to

ber No

vem

ber De

cem

ber

The
Peoplemover
1968:
A
Demonstration
Poem

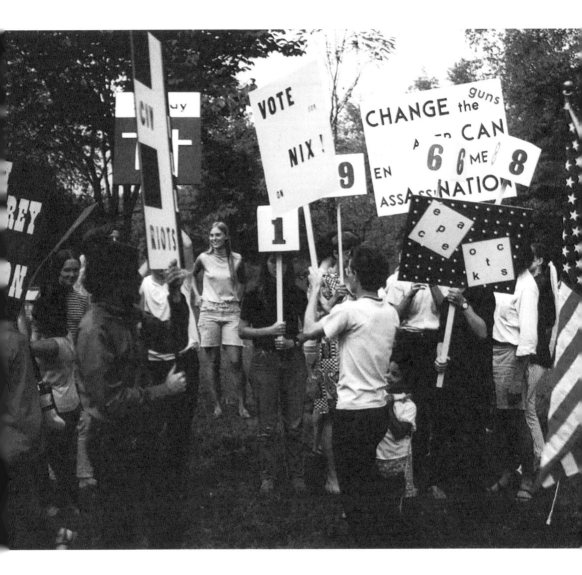

For Cathy and Susie

who

cut, sawed, painted,

and

demonstrated.

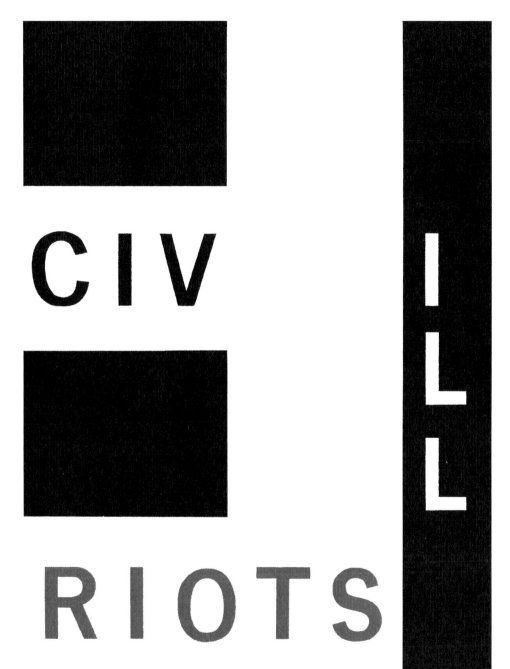

THY

KING DOM COME....

RESURR ACTION

CITY

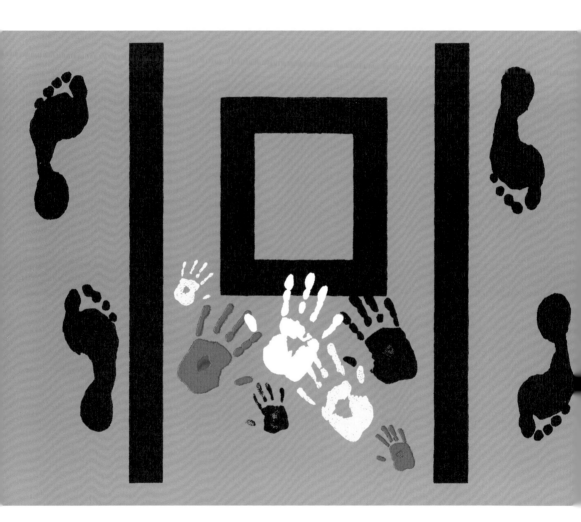

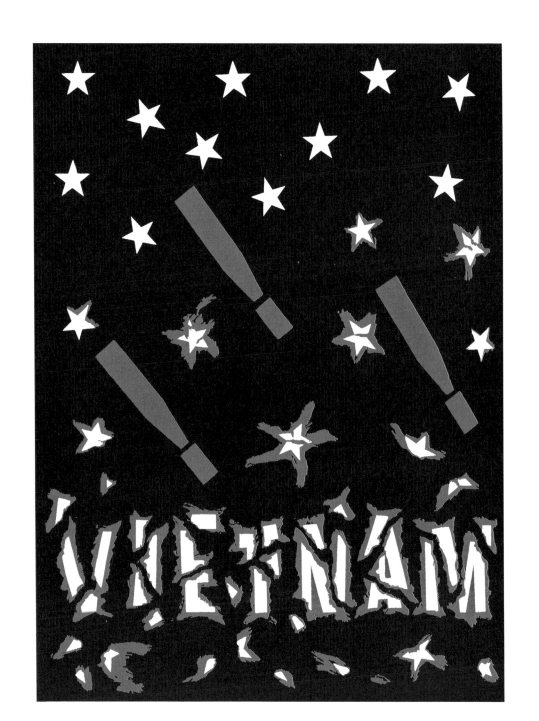

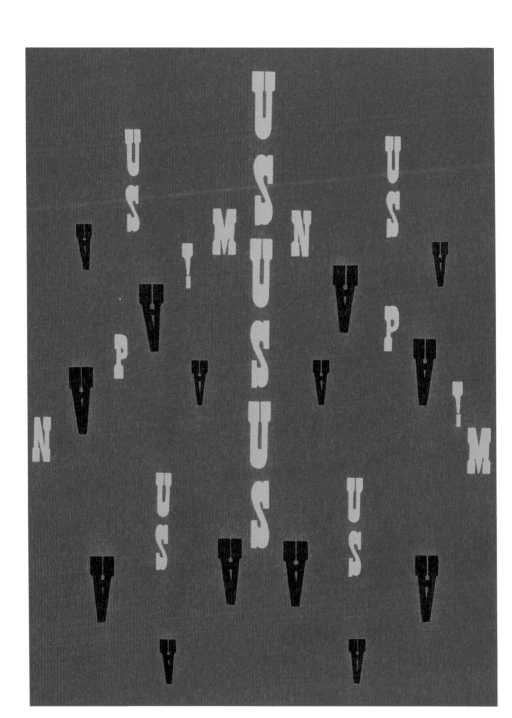

HUMPHREY ELECTION

VOTE

SON

NIX !

ON

Kennedy

CHANGE the guns

snipers AMER I CAN

EN VOIR ENMENT

ass Ass NATION

Marriage:
A
Code
Poem

MARRIAGE

A code poem derived from the universal language
of signs and symbols used from primitive times
to the present day:
the alphabet
astrology astronomy botany
chemistry commerce engineering
mathematics medicine
meteorology music physics
punctuation runes zoology &c.

◆ *dot : secrecy origin of all signs*

◇ *diamond female anatomical symbol*

♡ *heart*

♡̣ *composite symbol*

✡ *perfect marriage*

✡̣ *composite symbol*

L *length (terrestrial) lambert : unit of*
brightness right angle : meeting of the
celestial (vertical) and the terrestrial
(horizontal)

O *oxygen ocean blood type of*
husband and wife October (unofficial):
husband's birth month

V *potential energy velocity volume*

E *earth excellent*

LEO *husband's name*

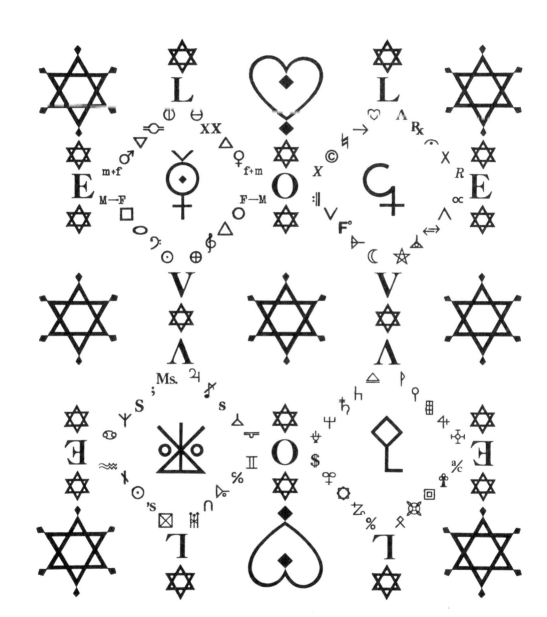

I Pairings

☿ sun (old oriental symbol) source of all life

⦶ active male element saltpeter

⊖ passive female element earth (with equator)

salt element: water

♂ male male flower

♀ female female flower planet Venus
mirror of Venus

▽ male element: water

△ female wisdom godhead element: fire

☐ male

○ female new moon unborn child God
eternity element : fire

𝄞 treble clef

𝄢: bass clef

☉ sun open eye of God element: air

⊕ earth creation: male plus female
sun cross element: earth

⊜ equivalent

△ finite difference

⬭ whole note

XX double strength

m+f ▪ f+m commutative law

M—F male implies female

F—M female implies male

II Conjugations

♀ Ceres : goddess of earth's fertility

♡ love

© copyright

⟺ reversible reaction

F° degrees of heat warmth

⌒ hold

♮ natural

:‖ repeat

V up-bow

Λ down-bow

A first class vessel

X kiss the unknown takes (chess)

∝ varies as

→ give

℞ take

X reactance

R resistance

☾ the moon's phases

⊢ man & woman united: procreation

⚸ pregnant woman

⛤ the five senses happy homecoming

III Family

❋ family: man with wife and children

S Solt school sulfur combustible elements

ς plural stem sire son sister series

's contraction: us is has possessive

↑ (rune: nied) necessity thraldom

Ψ man

△ woman

▷ woman bears child

⊙ moment of birth: awakening of inner
life in body

♎ Libra: astrological sign of father

♋ Cancer: astrological sign of mother

♊ Gemini: astrological sign of daughter

♒ Aquarius: astrological sign of daughter

♃ planet Jupiter: name of family cat

Ms. female of undefined status: name of family dog

% in care of

; related and continuing

∩ intersection: shared in common

⊠ simple activity

♪ appoggiatura: grace note

unity

IV Home

⚲ key

⌂ house

ᚹ (rune: wynn) comfort

▣ orderliness

✿ disorder

⌐ chair

♀ frying pan

⊥ fork

olive oil

vinegar

water

borax

wood

glass

lime

tree

$ money

ᵃ/c account

% mortgage

ᚷ (rune: ogal) possession

to exorcise evil spirits

V Relationships

⧖ Saracen talisman upper half: water
triangle kindness gentleness nobility
lower half: fire triangle God's fiery rage

☌ conjunction

☍ opposition

⎐ thunderstorm

⌒ rainbow

𝄪 double sharp

♭♭ double flat

☐ openness daylight

▦ concealment darkness night

= equal

≠ not equal

• dead ends stops

, continuations

◇ lying next to: touching but clear of

△ distance

λ wave length

÷ division

•• talk

∧ omissions

✳ afterthoughts

℈ scruples

VI Moods

☿ sign of Hermes (modification)
love's messages

|° degrees of feeling

→ approaches the limit of

○ wanting absence

◍ rain

⊕ solar halo

/ slashes

⊖ salt

⟠ eye of fire

⇺ drifting snow

↗ vitriol

♏ alum

♄ potash

⟠ annealing

⋮ to break and go on

♂ planet Mars war male

☮ peace

∿ ice storm silver thaw

‖ parallels

‡ double dagger poisonous

⊂ subset: contained in

VII Dimensions

⊕ the double cross: suffering holiness
outer circle: the finite
inner circle: the infinite eternity

the world worldliness nature

⧖ hour glass time

♉ season: spring

♋ season: summer

♏ season: autumn

♒ season: winter

♅ antimony: white metallic element
brittle lustrous

☉ annual plant: renewals

weathers directions

)(life's course: waxing and waning of the moon

√ (rune: yr) yew death

▨ multiform activities

friends

&c details

∼ turn: embellishments

△ creative intellect

≡ soul's journey in life: through darkness
towards the light (oriental symbol)

◎ outer circle: body
inner circle: mind
center point: soul

∅ the null: subset of every set

U the universe the universal set:
everything under consideration

VIII Conclusions

⊙ sunday: the wedding day holy day

! strong feelings certainties

E vessel fit to take on long voyages:
items resistant to sea damage only
excellent

♀ bolus: round mass of medicine
larger than ordinary pill dose

△ evergreen plant

⚓ anchor

♄ azurite lapis lazuli: deep blue stone

*| a new world

✳ a fixed star

A⅄ Amate! Love!

○ identity element: does not change
what it operates on

> greater than

< less than

≯ not greater than

≮ not less than

± plus or minus

√2̄ irrational

∧ conjunction: both are true

∴ therefore

Σ the sum

∞ indefinitely great

Letter
to
the
Editor
(later
poems)

dear sir or madam
 I'm sending some poems
for consideration for the magazine
(or is it a book) this isn't
one of them (i never send out
something I've just written)
 the problem is the form
ultimately it's not important
(i.e. after it's achieved)
but until it's achieved it's
everything

r. frost is a case in point
when he's great (and he is
often enough) if he hears the bounce
of tennis-ball words back and forth
and ends up with a winner—BRAVO!
but when he hears only big peas little peas
rattling in a pod—UGH! a thin book of
memorable poems would have been more
to everyone's advantage
 (but who's to say)

wcw listened to a staggering number of
revolutions of the wheel over dry leaves
before he heard the music in the desert
that great halloo
across international boundaries—
which brings me to the one concrete poem
I'm sending you—the only one I'd send you
that hasn't been published
 at this point in time
I'm not writing/making concrete poems

there's a lot of gleeful shouting lately
about the death of the avant-garde
about the failure of the international style
because it didn't/couldn't after all
save the world—part of an international
corporate fraud—concrete
is part of all that

but genuine art (even though misunderstood)
does not fail—what is genuine
in the international style
is of the spirit achieved by application
of principles of the machine
who sees universal failure
sees only the machine

LETTERS FROM AMELIA[1]

They come by airmail
always in regular envelopes
the kind with blue on the inside
that comes through like
 sky
below thick
 cumulus
 clouds
 airmail envelopes
strong
 light
 as butterfly
wings

Today enclosed
gift of some bird
a small gray feather
 picked from the grass
as she walked to her mailbox
asking:
 Do we work in vain?

the feather in its own outside envelope of
tissue
 enfolded in lacy soft rice paper
beneath a square of blue cellophane trapped
 in a tangle of
 silver
 threads

Who is Amelia?
I do not know her.
She reads my poems.

1. Amelia Etlinger was an artist associated with the Fluxus movement, visual poetry, and the Italian Poesie Vivisa community. She was born in New York City in 1933 and died in Clifton Park, New York, in 1987. Out of the blue she started sending her artwork to Solt.

Her first blue
letter
came pressed among junk mail
and bills—
 imagine opening it and finding folded
a piece of pale orange writing paper
tied with a purple ribbon fringed
in lavender chiffon—made by herself—
securing a spray of dried
 lavender
 weed flowers

 Can one bear to open it?
 Bear not to?

then another packet (more a folder) some
silky scrap of material
striped with pink ribbons secured by
tiny embroidered
flowers
 red-orange
inside a packet of sky-blue chiffon with more

 silver
 threads
 one strand of yellowed
cellophane

 some curled ravelings
 one soft fallen pussy willow
 a pressed purple violet
 one dry red petal
 a still-green leaf
 some brown
 leaf dust
no
words

Who could have sent this—

 like Emily D.—

 like Schwitters—

There's a photo enclosed: her
butterfly
blue
tapestry poem
these words on the
back:

 the summer moves
 on
 we live
 here
 but the
 sky
 is

 everywhere

How to reply?
Amelia doesn't wait for replies
Any day
for no reason at all there can come
a letter from Amelia:

One came once that was almost white
wrapped in cellophane the color of the sun
tied with an ancient scrap of
baby lace
below the cellophane a
handmade envelope of
plain white writing paper

then another—
pinkish white
fluted
edged in gold
next
two empty ones of
white
onion skin
then two final
packets of white
stationery—one inside the
other

containing:

 a wide gray-white satin ribbon
 a wide gray-white chiffon ribbon
 some pink and white threads with
 swirl knots
 securing a heart of
 white folded
 lace
 like a sachet
 stuffed with
 ruins of
 lacy brown
 fern

 and on a small white card
 that could have been
 lost
 letters in pale gray

 L O V E

LOVE from the
earth
and from Amelia

As though to proffer human love
 alone
takes risks
the heart can't bear

Once wrapped in Kleenex some
sand
and bits of dry
seaweed:

 a little love
 from the
 sea

Beautiful Amelia
 of the ribbons
 and wild flowers

Amelia of the
 sea spray

Where?
Who?
How?

 Do you live?

FELLOW TRAVELER

Across the aisle
the man
with screw-eyes
looked away
got up
reversed the seat
in front of him
grabbed
the pillow
its case pressed
immaculate
hugged it with
arms
worthy of
vulcan
as he tried to
stretch out
adjusting his massive
frame
to severe
limitations
the pillow
cradling his
neck
He dozed off
waking with a start
when the train
jerked
to a stop

PITTSBURGH

Jumping to his
feet he
grabbed
his suitcase
and with a wide
grin
tipped his
hat
and de-
parted

KAIROS

"Kairos," the "fullness of time," according to the New
Testament use of the word, describes the moment
in which the eternal breaks into the temporal, and the
temporal is prepared to receive it.
—Paul Tillich

it had been a long
ride—
the incessant rocking of the
womb
 to the rhythm of the
donkey—
 she was so
tired

 It was
different that day the
dove came
gliding down a ray of
light—
 that entered her—

giddy with the
news
 (she had to tell
someone)
 she hurried over the
hills
 of judah
to e-
lizabeth

 but this
 was bethlehem

had she felt
 the pain yet
when joseph
 (poor, mere
husband)
rapped
 at the inn door
(what was he to do)
did the innkeeper read the
terror in her eyes
or was it
 simply
the goodness of his
heart

 the mother of god lay
 moaning in the straw her
 rivers over-
 flowing

who helped her:
joseph
some friend
some woman from
nazareth
some luke whose
healing
touch could di-
minish the
pain's cres-
cendo

 two gentle hands
 to receive the re-
 jected
 god who
 gasped and
 cried like
 any
 child
 of
 earth

 she can't have dreamed it like
 that
 in her
 virgin
 modesty

 she must have dreamed a bed of
 lilies
 to birth the son of
 god

 suddenly it was all
 love-
 ly

 the holy child
 in the
 dazzling
 light

 the stable sub-
 merged
 in the shadows
 the animals
 were
 still

SEARCHING FOR THE GRAVE OF THE EQUILIBRISTS

it could be
here
where a poet lies
high on a
hill
 under a
portico

 at the foot of the
 hill in
 two
 more modest
 graves
 a
 president of the united
 states
 and his
 wife

 —a beautiful
 place
 as
 graveyards
 go

mr. ransom laid them
 in the
quiet
earth
close, but un-
touching in each
other's
sight
 and wrote their
epitaph

I've searched and
searched
 but
cannot
find
them

perhaps since they had no
legal
name
 they had no
claim to a
lot
 certainly not
one
 with a
stone

my lilies are
dying
 I'd better di-
vide them
quickly, give
half to the poet
under the
portico and
half to the
president's
wife who
must have been an ex-
emplary
lady

perhaps they re-
fused their
grave

how could they lie
there
parallel
watching the worms re-
joice and
smack their
lips
devouring what they
were de-
nied

no—the
grave is not fit
refuge for e-
quilibrists
 for
what can never
be can never
not
be

nor (i agree) is
hell (fit)
they'd earned no
circle
there
caught as they
were in
some dark
outer
rim
 of
earth
 to
burn e-
ternally

 like
 vanished
 stars

there's something in the
sky
 high over the
portico:

 lo
 two angels paralyzed
 in flight
 bathed
 in the
 beatific light of
 rings
 gleaming
 about their
 heads
 making an apex
 of the
 sun

and low
 a cloud of
 pigeons

flying

IN THE CATSKILLS
(for Susie)

the cosmic dialogue of
sun and cloud
whispers over the
mountains in a
shadow-dance of
light
and shade
crescendos in the
trees

tambourines

shaking
shimmering

The woman Aram Saroyan captures in his foreword to this book is undoubtedly Mary Ellen Solt at her most genuine. I speak for both my sister Catherine and myself when I say that our lives were immeasurably enriched by having such an extraordinary woman as our mother. She was an exuberant lover of life, for which she expressed near-daily gratitude. I so appreciate Aram's words, which beautifully celebrate and contextualize our mother's poems and her rich literary career.

Much of Mary Ellen's joy was due to her almost fifty-year marriage (1946–94) to our father, Leo F. Solt, a professor of English history at Indiana University, Bloomington. Although in many ways their marriage reflected the period in which they lived, they were true partners on the domestic front, an aspect of their relationship that was truly ahead of its time. Furthermore, before Mary Ellen received a professorial appointment and the associated benefits, Leo curated the professional space that nurtured her poetry practice and supported her initial endeavors as an independent scholar. Throughout the years, Leo was often the subject, object, or dedicatee of Mary Ellen's poems, and she cared devotedly for him in his final illness. On the publication of her collected poems, my mother would want our father's role in her life—to inspire, to love, to offer support, to free up her time, and to empower her career—to be rightly acknowledged.

As a small child, I was drawn to the energy that exuded from my mother when she was engaged in her creative work—her poetry and critical writing. And I cannot think of a time when I was not aware of the poet William Carlos Williams and his significance in her life. On July 27, 1960, Mary Ellen Solt delivered a talk entitled "William Carlos Williams:

 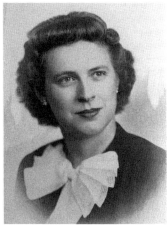

Leo F. Solt, c. 1946.
Mary Ellen Solt, c. 1946.

The American Idiom" to the Indiana University School of Letters, "one of the bastions of the New Criticism, then at its height."[1] As academic lectures go, it was a big event. Here is the backstory: In 1958, my mother wrote a paper on Williams's poetics, titled "The Shape of the Bridge," for R. P. Blackmur's School of Letters seminar Predictive Form. Blackmur insisted Mary Ellen send her essay to Williams. After some hesitation, she mailed it off. Mary Ellen need not have worried. Williams's enthusiastic response was immediate and overwhelming. My mother was invited to visit Williams and his wife, Flossie, at their home in Rutherford, New Jersey. Mary Ellen accepted the invitation, and a relationship among the three of them formed instantaneously and soon deepened. Two years later, the frail and aging William Carlos Williams traveled to Bloomington to hear my mother speak on his idea of the poem. While there, he stayed with our family. Williams had come, as my mother notes, "in pursuit of acceptance by the academy of his theory of the American idiom."[2]

Although Williams himself was respected as a poet, his views on poetry were not. In that period, Mary Ellen Solt was one of only a few critics who aligned with Williams's ideas, which were too radical for their time. To hear her defend his take on poetry before the cognoscenti was a rare experience that Williams could not miss. Here, in brief, is how Mary Ellen explains the American idiom as poetic theory:

> By making the speech of the people the center of his morality, his craft, and his vision, Williams has shown us—at a time when decadent, sterile "literary" practices and values have proved inadequate to the demands of our world and have brought into question the continuing usefulness of the poem—that the primitive need for and sources of the poem still exist, requiring only the poet who can establish and maintain his own contacts with persons, places, things and events, and who can articulate his experiences in an art form made from language that refers directly to them. We cannot divorce the poem from its time and place; from words that behave the way they do because they conform to the genius of a language. We cannot, in a word, divorce the poem from an idiom. What is more, we shall have to eliminate poetry that masks rather than reveals truth, poetry that presents hollow displays of technique for its own sake. We will have to demand of language the light and clarity of revelation.[3]

1. Marjorie Perloff, "Reading Mary Ellen Solt," in "Mary Ellen Solt: Toward a Theory of Concrete Poetry," special issue, *OEI* (Stockholm), no. 51 (2010): 32.

2. Mary Ellen Solt, "The American Idiom," *William Carlos Williams Review* 9, no. 1/2 (Fall 1983): 122.

3. Mary Ellen Solt, "William Carlos Williams: Idiom and Structure," *Massachusetts Review* 3, no. 2 (Winter 1962): 317–18.

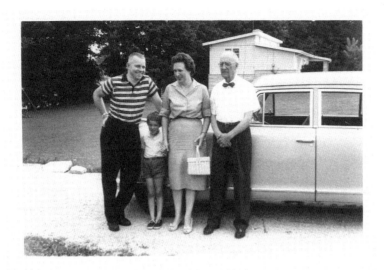

From left: Leo F. Solt, Susan Solt, Mary Ellen Solt, and William Carlos Williams outside the Solt home at 2001 Marilyn Drive in Bloomington, Indiana, on July 29, 1960. Photograph by John C. Thirlwall.

Mary Ellen's lecture in defense of Williams's idea of the American idiom proved controversial, prompting a raucous critical debate among the prominent academics at the talk. Afterward, Williams hid his disappointment at their opprobrium by focusing on an anomaly: the fact that the most renowned person in the audience that night was arguably not one of the literary lions in attendance,[4] but Walter J. Moore, a distinguished professor of chemistry at IU and a fan of Williams's poetry, who came on strongly in support of my mother and Williams. "As a scientist breaking new ground in his field," Mary Ellen noted, "he [Moore] could empathize with Williams' search for the American idiom."[5]

Later, Mary Ellen made the following observation regarding Williams's visit: "His experience at Indiana University, further distressing proof that the academy could not yet accept his theoretical stance, was beginning to coalesce into poetic statement."[6] This statement took the form of a poem Williams wrote about the lecture, "He Has Beaten about the Bush Long Enough," published in *Pictures from Brueghel and Other*

4. Attendees at Mary Ellen Solt's 1960 School of Letters talk included Edwin Cady, Glauco Cambon, James Cox, Richard Ellmann, R. W. B. Lewis, Newton Stallknecht, Harold Whitehall, and James Work. It was Cady who was particularly obstreperous and hostile to Williams. For a comprehensive account of Williams's trip to Bloomington and Solt's relationship with the Williamses, see Solt, "The American Idiom."

5. Solt, "The American Idiom," 104.

6. Solt, 108.

Poems (1962). This collection of poems garnered William Carlos Williams an elusive Pulitzer Prize in 1963, albeit posthumously.

He Has Beaten about the Bush Long Enough

What a team
Flossie, Mary, a chemistry prof
and I

make to confront
the
slowly hardening

brain
of an academician
The most

that can be said
for it
is

that it has the crystal-
line pattern
of

new ice on
a country
pool

Mary Ellen Solt contends that this poem, with its "sharpening of the visual qualities of the image to give the poem the final thrust to elevate the language to achieved form [. . .] shows us that Williams' innovations pointed the art of the poem in the direction of concrete poetry" at the end of his career.[7]

William Carlos Williams's cardinal role as a mentor in my mother's literary development cannot be overstated. Mary Ellen Solt felt a bond with Williams because of his belief in her poetic voice, and she owed him an intellectual debt for pointing her toward her own theory of the poem. Her takeaway from her School of Letters experience was to always anticipate pushback, but to forge ahead as a scholar and critic regardless, paving a path toward poetic innovation and invention and undergirding

7. Solt, 117.

her determined experimentation as a poet with a self-generated critical discourse that anticipated critique. Mary Ellen was acutely aware that William Carlos Williams had "never written the definitive prose treatise on idiom and culture that might have strengthened and clarified his new stance [on] the poem."[8] She would not make the same mistake.

In 2010, thanks to the eminent critic Marjorie Perloff, Mary Ellen's critical discourse (her career-long scholarly output of essays) was brought together in one volume. Perloff recruited Antonio Sergio Bessa to edit what was to become "Mary Ellen Solt: Toward a Theory of Concrete Poetry," a book-length issue of *OEI* magazine to which Perloff contributed a discerning introductory essay. In his foreword, Bessa did a magnificent job of appraising Mary Ellen's work and bringing interpretive nuance to her critical writing on Williams, concrete poetry, and the semiotics of Charles Sanders Peirce, while relating all of this to her own concrete poetry. "Toward a Theory of Concrete Poetry" is a vital companion to *The Collected Poems of Mary Ellen Solt.*

Before the publication of "Mary Ellen Solt: Toward a Theory of Concrete Poetry," it grieved me that my mother's innovative scholarship was consigned to little-read scholarly journals or, in at least two cases, not published at all. But the situation with Mary Ellen's poems was even more disheartening. Many were unpublished or published only in small magazines. My mother was too unassuming and reticent by nature to promote her own work, and at that point in her life, she was also distracted by my father's ongoing health issues; so, during a hiatus in my film career, I decided to take on the assembly, preparation, and editing of her collected poems myself. After that, it was simply a matter of waiting for the right time to release them into the world.

Now, with the publication of her collected poems in this volume, we can see Mary Ellen Solt's development as a poet, her evolution as she fluidly moves from practicing the principles of the American idiom in her discursive linear poetry to writing concrete poetry, and eventually return-ing to the poetic line, gracefully informed by her journey into the realm of concrete. I am thrilled that so many of my mother's poems, especially her pre- and post-concrete lyric poems, will be read here for the first time.

Without the Scottish poet and artist Ian Hamilton Finlay, it is unlikely that Mary Ellen Solt would have become the concrete poet and theorist we now know her to be. Although Marjorie Perloff notes that "as early as 1958, a number of years before she was exposed to concrete poetry," Mary Ellen "understood the central role that prosody—especially visual prosody—played in poetry; indeed, she wholly concurred with Williams's

8. Solt, "Idiom and Structure," 308.

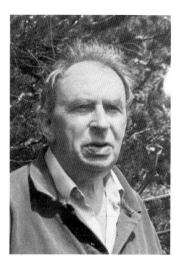

Ian Hamilton Finlay at home in Little Sparta, c. 1993. Photograph by Mary Ellen Solt.

definition of the poem as 'a machine made of words.'"[9] At the end of Leo's sabbatical year in London (1961–62), my mother met Finlay during a family trip to Edinburgh. Finlay shared his nascent concrete poems with Mary Ellen, as well as the poems and manifesto ("The Pilot Plan for Concrete Poetry") written by the Brazilian concrete poets (and brothers) Augusto and Haroldo de Campos and their colleague Décio Pignatari. Finlay also shared with Mary Ellen the work of Bolivian-born Swiss concrete poet Eugen Gomringer. This encounter with Finlay would change Mary Ellen Solt's life.

Back in Bloomington, Mary Ellen began corresponding with the Brazilians, with Finlay, and with Gomringer, and started writing her flower poems and pursuing other experiments in concrete poetry. Through these letters, my mother developed an abiding friendship with the reclusive Finlay, a friendship that would be fueled by forty-plus years of visits (accompanied by Leo and later me) to Finlay's family compound at Stonypath, in the Pentland Hills of Scotland. Mary Ellen established ties and negotiated a succession of friendships with the women who were instrumental in Ian Finlay's domestic and creative life: his partner and collaborator Jessie Sheeler (née McGuffie), his wife and collaborator Sue Finlay, and his confidante and collaborator Pia Simig. Stonypath featured what became Finlay's own Arcadia—his neoclassical garden, Little Sparta; as Francis Edeline remarked, "it's not hard to discern a shared, deep, long-standing interest in flowers" between these two poets.[10]

9. Perloff, "Reading Mary Ellen Solt," 33–34.
10. Francis Edeline, "Flowers and Fragments: On Ian Hamilton Finlay and Mary Ellen Solt," trans. Ken Cockburn, in *Poiesis: Aspects of Contemporary Poetic Activity*, ed. Graeme Murray (Edinburgh: Fruitmarket Gallery; London: Distributed Art Publishers, 1992), 47.

Plus, their views aligned around important things. Like Finlay, Mary Ellen Solt was not a conventionally religious person—hers was a personal faith, touched by the mysticism of her parents' Methodism. Yet, as Bessa notes, *Flowers in Concrete* "provides a hint as to how Solt might have worked out her religious upbringing through her creative process [. . .]. [Her] conversion of personal religious conviction into an aesthetic form that can be shared by all entails a deeply ethical outlook, which seems to have been a central characteristic of Mary Ellen Solt's life and work."[11] And, as Michael Archer observed in *Artforum* in 1991, "in the narrow sense Finlay is not religious," but "he abhors impiety of any kind." His "art is notable for its rectitude" and "principle."[12]

Ian Hamilton Finlay was the first to publish Mary Ellen's flower poems and other early concrete poems, which he placed in his influential 1960s magazine of visual poetry, *Poor. Old. Tired. Horse.* Following Finlay's introduction, nearly all the flower poems were published between 1964 and 1966 in the Belgian literary magazine *Labris*, edited by Leon Van Essche and Ivo Vroom. In the wake of this success, Henry Rago published "Marigolds" and "Dogwood: Three Movements" in *Poetry* magazine in March 1966. Thanks to this recognition in her home country, my mother began to feel confident that she was being taken seriously in American poetry circles.[13]

To advance her design and graphic skills, Mary Ellen studied drawing with her dear friend Alma Eikerman, distinguished professor of metal arts at Indiana University and an internationally renowned silversmith and jewelry designer. Eikerman introduced Mary Ellen to George Sadek, director of the graduate design program at IU. In 1966, Sadek agreed with Eikerman that one of his MFA graphic design students should design Mary Ellen's book *Flowers in Concrete* as a thesis project. John Dearstyne was chosen for the project.

When Sadek left to take a position at Cooper Union, Mary Ellen maintained a close relationship with the remaining members of the design faculty: George Luca, Marvin Bell, and Thomas Ockerse. She even enrolled in graduate classes in experimental and three-dimensional design. Another MFA design student at IU, Timothy Mayer, collaborated with Mary Ellen on the portfolio edition of *Flowers in Concrete* in 1969. After working closely with my mother, Mayer, his fellow design student David Noblett,

11. Antonio Sergio Bessa, foreword to "Mary Ellen Solt: Toward a Theory of Concrete Poetry," special issue, *OEI* (Stockholm), no. 51 (2010): 16.

12. Michael Archer, "The Divided Meadows of Aphrodite: Ian Hamilton Finlay," *Artforum* 30, no. 3 (November 1991): 94.

13. The dates of these publications and the many others related to *Flowers in Concrete* can be found in the bibliography.

and their mentor, Joe Lucca, received two awards for their 1968 book design for *Concrete Poetry: A World View*. My mother would want me to thank all of her IU design colleagues and collaborators who contributed to her personal design development and poetry projects.

Mary Ellen would also want me to acknowledge A. Doyle Moore, a good friend and the design principal at the Finial Press in Urbana, Illinois. In 1970, Mary Ellen and Moore collaborated on an exhibition set of smaller silkscreened *Peoplemover* posters while retaining all the emotional punch and color of the originals. That same year, Moore printed a beautiful pamphlet version of *A Trilogy of Rain*. In 1976, working closely with my mother's design prototype, Moore produced *Marriage*, Mary Ellen's poem composed entirely of signs.

In an essay entitled "Concrete Steps to an Anthology," Mary Ellen Solt writes that she "did not know enough to refuse" her IU colleague Willis Barnstone's invitation to guest edit an issue of the journal *Artes Hispanicas/Hispanic Arts* devoted to concrete poetry.[14] That issue evolved into a double issue, published in 1968 as *Concrete Poetry: A World View*, a book-length anthology that remains Mary Ellen's signature work of scholarship. As Nancy Perloff writes, more than fifty years later, of this classic work, "Solt set the stage; without her anthology, we would not know the genre."[15]

With hope and trust, poets from all over the world sent their work to Mary Ellen Solt for inclusion in what became *Concrete Poetry: A World View*. This action and energy spawned an international network not only of poetry, but of friendships that enriched her life enormously. As Bessa observes, "Mary Ellen seems to have found among poets a kind of extended family, to which she and her husband, Leo, opened their house."[16] Our houseguests over the years included not only William Carlos Williams and Aram Saroyan, but also Augusto de Campos and his wife Lygia, Haroldo de Campos, Eugen Gomringer, Ernst Jandl, Vagn Steen, Jonathan Williams, Ronald Johnson, Emmett Williams and Ann Noël, Cid Corman and Konishi Shizumi, Mike Weaver, Stephen Bann, Teddy Graham, and Alec Finlay. Receptions were held at the house for Karl Shapiro, Robert Creeley, Allen Ginsberg, Décio Pignatari, Max Bense, and Elisabeth Walther-Bense, among many others.

And let me recognize friends and colleagues from Mary Ellen's past who never made it to Bloomington: Louis and Celia Zukofsky, George Oppen, Denise Levertov, Charles Bernstein, Robert J. Bertholf, Emily Mitchell

14. Mary Ellen Solt, "Concrete Steps to an Anthology," in *Experimental – Visual – Concrete: Avant-Garde Poetry since the 1960s*, ed. Eric Vos and Johanna Drucker (Leiden: Brill, 1996), 347.

15. Nancy Perloff, ed., *Concrete Poetry: A 21st-Century Anthology* (London: Reaktion Books, 2021), 34.

16. Bessa, foreword to "Toward a Theory," 21.

Wallace, Dick Higgins, Richard Kostelanetz, and Graeme Murray. I would especially like to acknowledge the years of hospitality, support, and kindness that Florence "Flossie" Williams showed to my mother. I am also grateful to Williams's family members for supporting my mother's scholarship over the years and to the William Carlos Williams MD Estate for allowing us to include a facsimile of his April 25, 1960 letter to my mother in this volume.

I am exceedingly grateful to Willis Barnstone for championing my mother's concrete poetry composition and scholarship from the beginning and continuing to do so. It is because of Willis and his daughter, poet Aliki Barnstone, who published examples of Mary Ellen's concrete poetry in their anthology *A Book of Women Poets from Antiquity to Now*, that her poems have remained in print since 1980. I am also grateful to Willis and his son, poet Tony Barnstone, for their enthusiastic support while I worked to publish *The Collected Poems of Mary Ellen Solt*.

Marjorie Perloff was another influential proponent of Mary Ellen Solt's scholarship and poetry. She steadfastly supported the dissemination of Mary Ellen's oeuvre, including my work on this book. In addition, Marjorie and her husband, Joe, showed great kindness and hospitality toward my mother and me after my father died; this was in the mid-1990s, when I became dean of theater at CalArts and Mary Ellen moved to Los Angeles to live with me. It was fantastic for her to be warmly embraced as a member of the Perloffs' broad circle of friends, colleagues, poets, and artists so late in her career.

It is only fitting that Marjorie's daughter, Nancy Perloff, should have been the curator responsible for the Getty Center's 2017 exhibition *Concrete Poetry: Words and Sounds in Graphic Space*, which reestablished the significance of the concrete poetry movement for new generations. Like the Getty exhibition, Nancy's subsequent book, *Concrete Poetry: A 21st-Century Anthology*, prominently features Mary Ellen's concrete poetry and highlights her role in assembling and editing *Concrete Poetry: A World View*.

I am also grateful to curator Cecilia Alemani for including a stunning display of Mary Ellen's calligraphic versions of the flower poems in the 59th Venice Biennale in 2022. This retrospective event (and the press coverage in the *New York Times*, which heralded Mary Ellen Solt and the few other pioneering women in concrete poetry) proved that this groundbreaking movement had finally come back into focus through the lens of the women involved in it.[17] So it was as well with the 2020 publication of the anthology *Women in Concrete Poetry: 1959–1979*, in which editors

17. Robin Pogrebin, "A Diverse Venice Biennale," *New York Times*, February 3, 2022.

Mónica de la Torre and Andre Balgiu graciously gave just due to Mary Ellen Solt's influence and achievements.

I wish to acknowledge Breon Mitchell, director emeritus of the Lilly Library, professor emeritus of comparative literature, and Mary Ellen's former departmental colleague, for bringing my mother's extensive archive to Indiana University. Mary Ellen was an active correspondent, and her many letters to Williams, Finlay, and the rest of her extended poetry community are housed at the Lilly with the rest of her collection. I thank Erika Dowell, associate director and curator of modern books and manuscripts, and Isabel Planton, public services librarian, for their help with this book project as well.

I also wish to acknowledge Mary Ellen's other close and supportive colleagues in the IU comparative literature department: Matei Călinescu, Giancarlo Maiorino, and Claus Clüver, the latter of whom found his calling in concrete poetry. Mary Ellen and this mutually supportive team created IU's innovative program in the study of comparative arts, with concrete poetry as a signature offering. Mary Ellen was very grateful to IU semiotician Thomas Sebeok for his support of her forays into the papers of Charles Sanders Peirce, and to composer Iannis Xenakis for letting her take his class at the IU (now Jacobs) School of Music.

In the autumn of 1976, I traveled with my mother to Poland, where we would spend the academic year. She had been appointed to the English Department faculty at the University of Warsaw as an exchange professor at the newly established American Studies Center. It was not long before Marek Hołyński presented Mary Ellen with a copy of his book *Sztuka i komputery* (Art and computers). Much to our surprise, Marek had included her poem "Lilac" in its pages. Soon, Mary Ellen was introduced to the leaders of the Polish avant-garde, including Stanisław Dróżdż and Ewa Partum. My mother and I spent a stimulating year in Poland while she gave talks on concrete poetry throughout the country. Her concrete poems were exhibited in Warsaw at the Remont and Foksal galleries during our stay.

As a Romanian exile from a Communist regime, fellow avant-gardist Matei Călinescu offered this knowing perspective regarding Mary Ellen's singular Polish connection:

> [A]s an American intellectual, she was not only esteemed by her peers in Poland, but she represented for them a trusted link to the outside world, something of great value in a closed and tightly controlled society. She, as an open-minded, curious, sincere person, and moreover as a noted avant-garde poet from the West, was a focus of interest and genuine affection in Poland. Human relations in Eastern Europe at the time could be unusually warm [. . .] in contrast with the official ideologically frosty atmosphere and with the pervading sense of social alienation [. . .]. Mary Ellen experienced

in Poland a special kind of loyalty, cordiality, and friendliness that she could only take to heart. And hers was a big heart.[18]

Thanks to the year she spent in Poland, "cultural ambassador" was added to Mary Ellen Solt's list of professional roles, among them poet, critic, scholar, and teacher. "Academic administrator" was added upon her return to IU, where she was appointed director of the Polish Studies Center, a position she held until 1984. At Indiana University, George Brooks, John Lombardi, Grace Bareikis, and Ivona Hedin were valued colleagues during Mary Ellen's term as director. In the field of Polish studies, her closest academic colleagues were Romuald Kudlinski, Włodzimierz Siwiński, and Andrzej Bartnicki.

I wish to acknowledge the love and support of Margaret Wolfson, who began her career as a poet and professional wordsmith in my mother's classroom at IU, studying the poetry of William Carlos Williams. Mary Ellen loved teaching; it was her first calling. In the IU Department of Comparative Literature, where she taught from 1970 to 1991, she led classes on concrete poetry, Williams's poems, modern poetry, and literature and the arts. Over the years, I have heard from many of my mother's former students, who speak of her with warmth and admiration.

My mother also loved her early college mentors. At Iowa State Teachers College (now the University of Northern Iowa), Mary Ellen first studied classical piano with concert pianist Louis Crowder. Mary Ellen was a fine pianist. As a little girl growing up during the Depression in small-town Iowa, she was not only a precocious talent but dogged at her practice of classical music. The piano was her passion and saving grace. She soon assumed the role of church pianist, playing regularly before her preacher father's congregations. In college, however, Mary Ellen soon realized she was not temperamentally cut out for a concert career. The dynamism of H. Willard Reninger, professor of English, turned my mother's passion for learning from music to literature.

Mary Ellen's serious and disciplined music training primed her appreciation of poetry and her understanding of prosody. It gave her unique insight through musical structure into Williams's search for the American idiom and the "relative measure" of his "new metric," the "variable foot."[19] Her musical lexicon and her ear for tempo and rhythm infused both her linear and concrete poems. Music even dictated how she constructed her relationship as a poet to space on the page. Her familiarity with musical notation made her comfortable with signs, and through music, she also grasped theory.

18. Matei Călinescu, "In Memoriam: Mary Ellen Solt," *Encompass: Alumni Newsletter* (Indiana University Department of Comparative Literature) 18 (Summer 2008): 10.
 19. Solt, "The American Idiom," 96.

New York City was Mary Ellen Solt's mecca for music and poetry. In 1948, when Leo began his doctoral studies in history at Columbia University, Mary Ellen embraced New York with enthusiasm, her adventures subsidized by her teaching job at the Bentley School on the Upper West Side. My mother told me she was so eager to take advantage of all the city had to offer that she once realized she had inadvertently purchased a full week's worth of concert tickets to Carnegie Hall.

Even more than Carnegie Hall, Mary Ellen Solt's second home in New York was the 92nd Street Y, where she attended countless poetry readings, including Dylan Thomas's first American readings onstage and an appearance by T. S. Eliot in which he read "La Figlia che Piange." She also saw Marianne Moore, W. H. Auden, Robert Frost, Wallace Stevens, and many more read in person (though not always at the Y). Mary Ellen even heard William Carlos Williams read once; at the time, he impressed her less than many others. She also studied the craft of poetry: at Columbia, with Leonora Speyer, and at the Poetry Center, with John Malcolm Brinnin and Kimon Friar, among others.

<p style="text-align:center">⋆ ⋆ ⋆</p>

On a personal note, I am indebted to my sister, Catherine Solt, for her support over the years, her concern, and her loving care for me and our mother and father. As Mary Ellen's first child, my sister shared a unique and surpassing emotional bond with our mother. She has been by my side throughout the process of bringing these poems to print.

I am immensely grateful to my dear friend Joanna Miller for her joyous enthusiasm for this project and her generous donation in material support for *The Collected Poems of Mary Ellen Solt.*

I am delighted to acknowledge the editorial, design, and publishing team at Primary Information for their care and commitment to the stewardship of this book. Matthew Walker, executive director, and James Hoff, executive editor and artistic director, have been exceptional in their support, judgment, and enthusiasm. I admire them both enormously for their ethos and aesthetic as publishers; they have been exceptional in making concrete poetry and its legacy part of their catalog. Their choice of Ryan Haley as managing editor, Bryce Wilner as book designer, and Allison Dubinsky as copy editor has contributed immeasurably to the successful publication of the manuscript I presented to them at the outset of our collaboration—my heartfelt gratitude to one and all. Mary Ellen would be so pleased with the results.

Susan Solt

Calligraphic Flowers (1963–65)

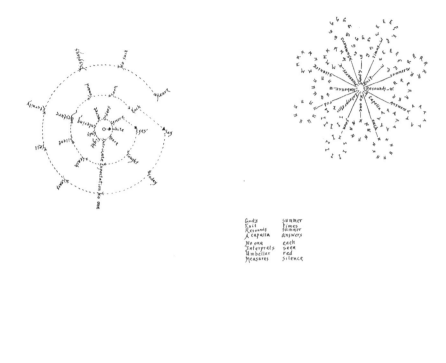

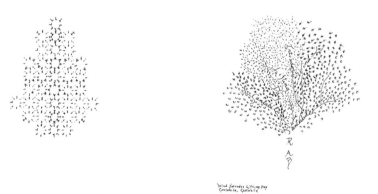

Each of the flowers, shrubs, and trees that appear in the eleven poems in Mary Ellen Solt's most famous work, *Flowers in Concrete*, grew in the yard, the beds she planted, or the woodland border of her home in Bloomington, Indiana. Solt would stand for hours, looking out the window with a piece of onionskin paper pressed against the pane, sketching what flourished in her garden. The resulting poems, these original calligraphic versions, were drawn between 1963 and 1965.

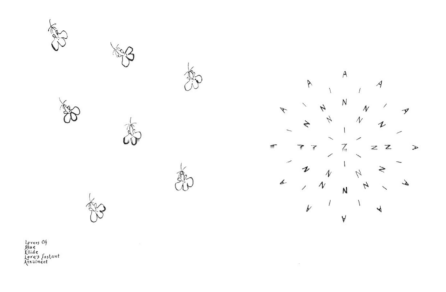

Lovers Of
Blue
Elide
Love's Instant
Annulment

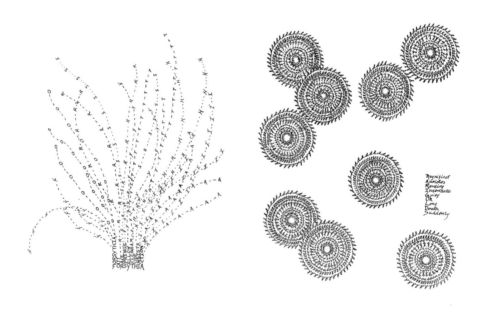

FORSYTHIA

Magnificat
Aborideo
Rousseau
Immoderate
Or
Long
Death
Suddenly

Calligraphic Flowers (1963–65)

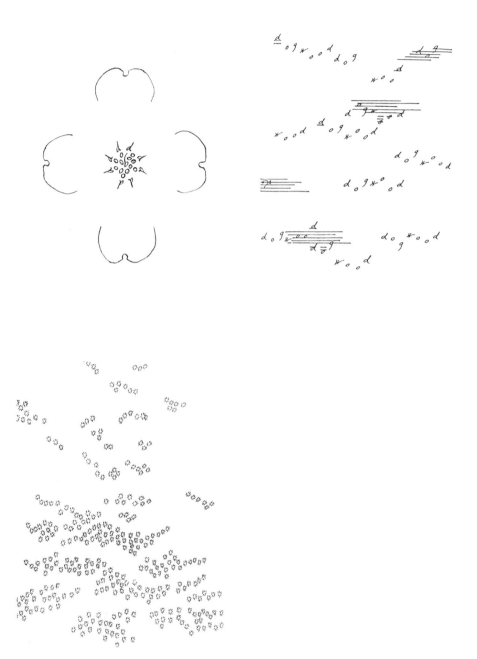

Calligraphic Flowers (1963–65)

April 25, 1960

Dear Mary:

Flossie read me your poems this morning. They are excellent,
they are so excellently conceived and executed that I do not trust
myself to praise them as man to a woman - too much is involved. We'll
be talking about this book, and the books that follow it, as long
as we exist in this world. I have spoken of you in a letter I wrote
this morning to Harold Norse as one he should heed from Paris as a
comer.

P. 36 for some reason is one of the best for a number of
reasons - but no better than a number of others. Your absolute
intellectual honesty hits me right between the eyes - and you have
an outstanding brain only equaled by your flagrant courage.

I dont know, Mary dear, whether you will be able always to
stand up against the challenge that implies in a womans life. Art is
the sole release for both man or woman but a woman is more
vulnerable in the world's eye. You are intensy sexual, wonderfuly
sexual, as Sappho was but she had to be a lesbain to exist in a world
where men are expected to take a leading place.

- If she had to retire among her own sex to survive as a poet
you may imagine what will happen to you. Such a woman as Edna St
Vincent millay had to retreat into the sonnet to survive, H.D. has to
retreat to the Imagists and Marrian Moore - who has survived
credibly has tortured her verses into cnventional posture when it
cannot be told whether a man woman or neutral wrote them, She is
what amounts to a nun. God bless her.

but youd a full blooded woman, with a husband who cannot be
sacrificed even if you should want to.

and you have a conception of the poetic line which is
revolutionary and may lead you anywhere, with its implications -
and besides yous are a woman.

Work at your lines - as you will without my urging, pruning them
to most concentrated essence without showing any strain that they
are capable of. Sappho be an example to you - what little we have
of her.

The reast is up to you, bless you, make it brief, singing, a
cry from the heart as a woman must talk - and all cries from the
heart are short and cryptic.

All my lying love to you

Notes

What the Girl Might Have Said

The lyric poems grouped under this heading were written between 1957 and 1975. In the spring of 1960, Mary Ellen Solt gave a selection of her poems to William Carlos Williams. His response to the poems, including, more generally, his thoughts on women poets, is reproduced on the preceding page.

In her writings, Solt commented on the letter:

I received this remarkable and very moving letter from William Carlos Williams after I returned home from visiting him in Rutherford [New Jersey], April 18–19, 1960. He had been very supportive of my work on his poetics of the American idiom since 1958, so I thought he wouldn't mind taking a look at a few poems as well. I was astounded when I read the letter. I didn't feel that I had earned the praise, and I wasn't at all convinced that I could live up to it. But the letter isn't written only to me or about me. It is a letter from a great poet and a most compassionate and empathetic man to all poets who happen to be women. It expresses his lifelong love of all women, his respect for them, his reverence for the female principle, his fascination with woman in all her complex intellectual and emotional dimensions.

The Harold Norse whom Williams mentioned in the letter's first paragraph had recently had his translation of *The Roman Sonnets of G. G. Belli*, with "Preface" by William Carlos Williams, published in *Jargon* 38 by Jonathan Williams. Williams had spoken to me about the book when I was in Rutherford.

The poem of mine he singled out [. . .] was "With Child." It equated pregnancy with phenomena and processes in nature. It spoke of growing "round as the / earth grew round" and "blunt" as the "plum shapes" itself "to the sun's

full / outline." The pregnant mother was equated with "the sky where a / wing beats" and "the sea where a / fish swims" in her "forever." The poem ended with a question: if the pregnant mother can be equated with these natural processes and cosmic implications, why does she "want to vomit / the thing"? Of course I was elated that Williams liked the poem, especially since I was determined to make poetry of my woman's life, and the rejection slips from male editors were piling up higher and higher. One of them had the honesty to admit that he found my subject matter uninteresting. Many years later *13th Moon* accepted "With Child" for publication.

I remember being rather taken aback by Williams' admonition relating to "a husband who cannot be sacrificed even if you should want to." Although there was rebellion in the poem against the confines of the marital state, it was not directed to the end of sacrificing anyone else. Perhaps Williams simply wanted to warn me against exploiting the people I love and using my poetry as an excuse for not meeting familial responsibilities. It cannot be charged that Williams broke his fundamental commitments to his family despite lapses and infidelities over which he grieved deeply.

The closing phrase "All my lying love to you" is more a statement about the nature of love than a personal declaration.[1]

Flowers in Concrete

One day in March of 1963, I wanted to write a poem about some yellow crocuses blooming outside my window in the snow. I had been trying to read the Portuguese-language anthology of Brazilian concrete poetry, *Poesia Concreta*, with the aid of a dictionary. (Ian Hamilton Finlay had introduced me to Brazilian concrete poetry when I

1. Mary Ellen Solt, "Notes on a Letter from William Carlos Williams," *William Carlos Williams Review* 11, no. 2 (Fall 1985): 2–3.

visited him in Edinburgh the preceding August.) I had probably read the "Pilot Plan," but I didn't begin to understand it. Nonetheless, I began to make a poem from words beginning with the final letters of the words I had made from Y-E-L-L-O-W C-R-O-C-U-S. Also, the form seemed to want to be circular, moving out from the center, so I found myself turning the page around and around. When I had finished, the serial order of the words and the page turning round and round seemed important to me; also, I felt that making my own letters and from them a visual object had brought me closer to words than I had ever been before. But I knew immediately there was something wrong with the poem. The circular form moving out from the center had nothing to do with the way crocuses grow, and the words were not closely enough related to each other. It occurred to me, though, that the form I had just made was suitable for a poem about a rose, for the rose grows in circles out from the center. So I wrote a poem called "White Rose," which I sent to Finlay. To my surprise he published it in *Poor. Old. Tired. Horse.* I went on to make a book of hand-drawn flower poems in which I attempted to relate the word as an object to the object to which it refers by studying the law of growth of the flower and making a visual equivalent. I called this book *Flowers in Concrete.* If there was a text, I used the serial method based on the letters in the name of the flower. When the text could not be incorporated within the visual pattern, I made two poems: a serial text and a visual object ("Lobelia" and "Marigolds"). There were some one-word poems ("Zinnia" and "Lilac"), and in two instances I found an identity between the form of the letters and the form of the flower ("Marigolds" and "Dogwood: First Movement"). The poems were primarily expressionistic, but I felt the need for a formal system inherent in the words.

"Forsythia," made from the letters of the word and their equivalents in the Morse code, is one of these poems. When John Dearstyne was able to make typographical versions of all but one of the calligraphic originals ("Dogwood"), I knew I would have to face up to the problem of typography. There is no doubt in my mind that I feel closer to words when I make my own letters, but the machine makes them so much better.[2]

As with most concrete poetry, the flower poems lend themselves to visual display. The poster-size versions, completed in 1969 in collaboration with designer Timothy Mayer, have been exhibited many times, and the calligraphic versions have also been exhibited throughout the years. A non-exhaustive list would include: Galerie Denise Davy, Paris (1968); Galerie nächst St. Stephan, Vienna (1968); the 34th Venice Biennale (1968); Instituto Torcuato di Tella, Buenos Aires (1969); the Jewish Museum, New York (1970); Stedelijk Museum, Amsterdam (1970); MoMA, New York (1970); Geijutsu Seikatsu Gallery, Tokyo (1970); Galleria S. Chiara, Brescia (1971); Galeria Remont and Galeria Foksal, Warsaw (1977); the 38th Venice Biennale (1978); Galeria X, Wrocław (1979); Fruitmarket Gallery, Edinburgh (1992); the Getty Center, Los Angeles (2017); and the 59th Venice Biennale (2022).

Words and Spaces

The concrete poems that make up "Words and Spaces" were written over three decades, from the 1960s to the 1980s. Except for "Moonshot Sonnet" and "ZIGZAG," the poet originally created them on a manual Olympia typewriter. Solt had planned to produce a portfolio edition of many of the poems in this collection; however, she never completed the project. A record of these efforts is part of her archive at the Lilly Library, Indiana University. In the early 1990s, Susan Solt, with support and guidance from her mother, created the versions of the poems that appear in this volume; they are based on the incomplete portfolio edition.

2. Adapted from Mary Ellen Solt, *Concrete Poetry: A World View* (Bloomington: Indiana University Press, 1970).

What is a word?

According to Webster a word is a speech sound or a series of speech sounds that conveys meaning. Or it is a group of letters, written or printed, that represents meaningful speech sounds. Traditional poetry focuses primarily on the spoken word. Concrete poetry invites us to consider words not only as symbols that convey meaning but as things in themselves. Think of a word and of each of the letters of the alphabet of which it is composed as material objects occupying space. The Noigandres Group of Brazil, who along with Eugen Gomringer of Switzerland founded the international concrete poetry movement, defined the space of the word (and by extension the space of the poem) as verbivoco-visual (semantic-aural-visual). This three-dimensional view of the word was realized in poems based on a new spatial concept of form: the ideogram.

By studying the deployment of words on the page, their visual relationships and juxtapositions, the reader enters into the process of the poem and creates a meaning. Gomringer employed, for the most part, a technique of word repetition, creating what he called constellations. Both Gomringer and the Noigandres Group (Augusto de Campos, Haroldo de Campos and Décio Pignatari) cited "Un Coup de dés" (1897), a revolutionary poem by the French symbolist poet Stéphane Mallarmé, as the seminal work from which the possibilities for concrete poetry evolved. Mallarmé used the white page rather than the line as his organizing structural principle. And he used typography as a function of meaning by adapting point size and typeface to each of the poem's several themes. The title and principal theme—UN COUP DE DÉS JAMAIS N'ABOLIRA LE HASARD—was printed in uppercase with the largest type. Italic type with smaller letters was used for the vertigo-feather-siren theme. Page space assumed the function of punctuation.

The international movement Concrete Poetry came into being when Décio Pignatari of the Noigandres Group and Eugen Gomringer met by chance at the Hochschule für Gestaltung in Ulm, Germany. Pignatari, a graphic designer as well as a poet, had gone there to consult with Max Bill, the leading concrete painter and sculptor, [and] director of the school. Gomringer was serving as Bill's secretary. The two poets discovered that they were making essentially the same kind of new poems. After Pignatari returned to Brazil, the Noigandres Group and Gomringer discussed the possibility of publishing an international anthology. They settled on the term "concrete poetry" because they wanted to stress their belief that the new poetry represented the literary sector of the field already occupied by the concrete art of Bill and his colleagues. Concrete art is a type of Constructivism clearly exemplified by the painting of Piet Mondrian, an art based on mathematical principles and on purification of the language (or materials) of painting. Mondrian's vocabulary consists of the primary colors red, yellow and blue; the non-colors black, white and grey; and horizontal and vertical lines meeting at right angles. Concrete poetry participates in the great cleansing of materials evident as both a need and a process in all of the arts during the twentieth century. In his long poem *Paterson*, the American poet William Carlos Williams agonizes over his responsibility as a poet to clean up the words, to revitalize a language divorced from meaning. Williams is cited as a precursor by Gomringer. The first Brazilian concrete poems, written by Augusto de Campos, were an attempt to capture with words the purity of isolated tones he heard in the *Klangfurbenmelodie* of Anton Webern. But while it is important to emphasize the relationship of concrete poetry to the other arts, it is equally important to note that the poets who invented it were well aware of their literary predecessors. In addition to Williams, Gomringer mentions the innovative German poet Arno Holz. The Noigandres Group acknowledges great indebtedness to the ideogrammic method of Ezra Pound in the *Cantos*,

to the word ideograms of James Joyce in *Finnegans Wake*, and to the typographical innovations of e. e. cummings.

Once the movement had been founded in 1956, it was discovered that there were other poets in other countries writing in different languages [and] engaged in similar poetic experiments. This cannot be insignificant. Perhaps it points to particular needs relating to human communication following World War II, which can be seen as a cataclysmic breakdown in human communication. Concrete poems for the most part do not require translation; they can be read by nonspeakers of the language with the aid of a word gloss. Gomringer proposed the ideal of a universal community language whose model for poetry would be the international airport, where people from all over the world communicate with a minimal number of signs. The quick visual message exemplified in his airport model he saw as typical of language usage and communication in the twentieth century. We are bombarded with quick visual and audio-visual messages and abbreviated content [and] techniques employed by the mass media, many of which aim at a high degree of conciseness, the goal of all poetry. The concrete poet is faced with the challenge of conveying a message with one or a few words, sometimes with a single letter or sign. Space, type style or a calligraphic gesture of the human hand are all part of the meaning of the poem. The message conveyed is also affected by the number of words used and by the number of times a word is repeated. The concrete poem is always about language.

Concrete poetry asks us to look at the word: at its aesthetic properties as a composition of letters, each of which is a beautiful object in its own right, especially when it has been printed in a typeface designed by a typographic artist. The importance of expert typographers to concrete poetry cannot be overstressed. The typewriter (and now the word processing computer) also become instruments for artistic expression. Concrete poetry asks us to contemplate the relationship of words to each other and to the space they occupy We must be prepared to contemplate poems as constellations of words, as ideograms, as word pictures, as permutational systems. By discovering the meaning of the poem as it emerges from the method of its composition, the reader becomes in some sense the poet.[3]

The Peoplemover 1968: A Demonstration Poem

Spurred by outrage over the war in Vietnam, anger over the crisis in race relations, grief at the assassinations of King and Kennedy, and a profound sense of despair over the collective state of the nation, Solt embarked on the creation of *The Peoplemover 1968: A Demonstration Poem*. She conceived and constructed (with help from her daughters) seven double-sided poster poems that together constituted a protest message and a call to political action during that turbulent year.

"The Peoplemover" takes its title from the famous conveyance in Disneyland. Day and night, the PeopleMover transported crowds of fun-seeking Americans around a world of fantasy and fabled history. In the real world of 1968, the people mover was the demonstration. Seeking its place in the world, "The Peoplemover" poem grew in response to the demands of particular staged demonstrations with the poster poems. It was first performed as a pre-election event by Donald Bell's experimental design class at Indiana University, Bloomington on 7 August 1968. There was no script: only a Dadaesque "demonstration" performed to a recording of John Philip Sousa's classic march "The Stars and Stripes Forever," blasting on a phonograph. A second

3. This text was written by Mary Ellen Solt circa 1985.

pre-election "demonstration" was held on James Brody's lawn out in the country near Bloomington on 22 September. The demonstrators were members of the Fiasco group: painters, poets, musicians, sculptors, dancers, who met on Sunday afternoons to critique their artworks. No one else was aware that a demonstration was being held (except my teenage daughter Susie, who lobbied earnestly to be included), but the demonstrators enjoyed letting off steam. Timothy Mayer provided some record by taking a few photographs.

Some of the participants, particularly Franz Kamin, felt that some kind of script was needed to give the "demonstration" more of a structure. So when "The Peoplemover" was next performed at the Owl in Bloomington on 16 November, just following the election of Richard M. Nixon as president of the United States, a short historical text with statements from the past was read by myself as the posters were shown to the audience. At the end of the reading patriotic music was played and the audience "demonstrated."

On 20 February 1970, "The Peoplemover" was again performed as part of a program devoted to expanded forms of concrete poetry during [the] month-long exhibition *Expose: Concrete Poetry*, held in the Indiana University Memorial Union, Indiana University. On the same program Emmett Williams presented his multimedia poem "5,000 New Ways" and Vagn Steen of Denmark a dance poem. On this occasion, "The Peoplemover" received a fuller multimedia treatment. A longer historical script (the basis of the long montage of historical utterances eventually published by *West Coast Poetry Review*) was read by Rose Daley, William H. Harris, my husband Leo and myself, while Joseph Zentis projected corresponding historical names, titles, dates and places on a screen. Throughout the reading a quiet demonstration took place in the aisles. When a particular poster was being featured in the reading, that demonstrator stood facing the audience. Fragments of patriotic songs and marches were played at the beginning and end, when the members of the audience were invited to join the demonstration. Ideally "The Peoplemover" should have been performed in the streets or on the courthouse lawn.

Eugene McCarthy has characterized 1968 as "The Year of the People." The people were heard. President Lyndon Baines Johnson chose not to seek a second term in the face of opposition to and demonstrations against his war policies. And while reaction to the demonstrations and protests of 1968 undoubtedly contributed to the success of Richard M. Nixon at the polls, it is now, since Watergate, apparent that his own inability to deal psychologically with the democratic right of citizens to differ, to protest, contributed greatly to his failure in office. The 1968 movement of the people—despite its immediate political defeat—was not, then, inconsequential.

The Fiasco demonstrators were right. "The Peoplemover" needed a script. But could the voice of the poet be heard above the lying political rhetoric and the roar of protest that was destroying political parties and heads of state? It did not seem likely. I remember that William Carlos Williams used to listen to the speech of the American people and read historical documents in his search for the American idiom. He said he was searching for those rare instances when some American—some human being—achieved in words an articulation of the truth: spoke as a poet. It seemed that surely there must be an authentic, fragmented dramatic poem in the utterances of the people deeply involved in the events of 1968. Above the shouting, despite the ever-widening gap between the truth and the public statements of the powerful, anguished and soul-searching outcries by people like Martin Luther King, Robert Kennedy, and Eugene McCarthy could be heard. Their words interwoven with words spoken or written during other periods of crisis in our history could, it seemed, provide a truer insight into the events of 1968 than any text a poet might create. And it is perhaps a comfort to be reminded that we have had and hopefully will have

again national leaders who could sometimes speak as poets.[4]

In 1975, Mary Ellen, Leo, and their daughter Susan traveled to the Catskill Mountains to participate in a performance of *The Peoplemover* at Sonora House. It would prove to be the last time the poet was directly involved in a performance of the poem. Margaret Wolfson and Judith Martin, former students of Solt's, had founded Sonora House as a performing and producing ensemble in Haines Falls, New York. Wolfson incorporated projected images of the posters and photographs of historical events into this staging of the text version of *The Peoplemover*. The musical accompaniment included Martin's wildly original interpretation of the "Battle Hymn of the Republic."

In 1970, Mary Ellen Solt produced a design collaboration with A. Doyle Moore: an exhibition set of the original *Peoplemover* posters, produced as color silkscreens by the Finial Press, Urbana, Illinois. This version of *The Peoplemover* posters has been published twice alongside the performance text. Therefore, the decision was made to let the posters stand alone in this volume as the poems they were originally conceived to be.[5]

Marriage: A Code Poem

The significance of *Marriage*, Mary Ellen Solt's intricate poem composed entirely of signs, reflects the poet's sincere fascination with the poem as a sign. For years, she studied the writings of Charles Sanders Peirce, learning about the sign in its various forms as "icon," "index," and "symbol."

"Marriage" came into being as an attempt to rise to the challenge of a statement made by the composer Iannis Xenakis. Music, he said, was capable of handling more complex subject matter than poetry or painting. I assumed he meant lyric poetry, not the great poetic dramas. "What is the most complex subject I might attempt to deal with in a poem?" I asked myself. "Marriage," I concluded. But I knew that if I attempted to write about marriage in a traditional poem made of words in sentences, Xenakis would win hands down. The concrete poem with its concentration upon one or few words was also inadequate. But within the genre of concrete poetry, the semiotic poem had been created by Décio Pignatari and others: visual poems consisting of a few signs accompanied by a word gloss (or code). The semiotic poem, it was argued, can send a clearer and more efficient message than can be imparted by words. It occurred to me that if I could find (or create) a sufficient number of signs to function literally or metaphorically, I could compose them into a visual image, to be interpreted by means of an accompanying code, that could serve as a supersign of the complex human relationship—marriage.[6]

Working again with A. Doyle Moore at the Finial Press, in 1976 Solt designed a book version of *Marriage*, with type set by her daughter Susan and linocuts by Sheryl Nelson.[7]

Letter to the Editor (later poems)

Solt returned to writing linear poetry late in her career, and these lyric poems are the proverbial poems left in the drawer. Her journey as a concrete poet was coming to its natural end, and she was ready to tackle the poetic line once more.

4. Mary Ellen Solt, *The Peoplemover 1968: A Demonstration Poem* (Reno, NV: West Coast Poetry Review, 1978).

5. For a complete publication history of *The Peoplemover*, including posters and performance text, please see the bibliography.

6. Solt's daughter Susan found these comments in a file folder labeled "Marriage" in Mary Ellen Solt's home office in the early 1990s. The contents of Solt's poetry files are now part of her archive at the Lilly Library, Indiana University.

7. See the bibliography.

Bibliography

What the Girl Might Have Said

Previous publications include "Seascape" and "The Tattooed Lady" in *Folio*, Spring 1960; "For William Carlos Williams" in *Beloit Poetry Journal* 14, no. 1, Fall 1963; "What the Girl Might Have Said" in *Poor. Old. Tired. Horse.*, no. 6, 1963; "Bird," with a drawing by John Furnival, in *Poor. Old. Tired. Horse.*, no. 13, 1965; "The Visitor" in *Quickly Aging Here: Some Poets of the 1970s*, Garden City, NY: Anchor Books, 1969; "Mediterranean" in *Stoney Lonesome*, no. 6, 1975; "The White Flower" and "With Child" in *13th Moon*, Winter 1975; and "This Is Easy" and "Touch" in *American Poetry Anthology* 8, no. 1, 1988.

Flowers in Concrete

The complete series of flower poems was first published as *Flowers in Concrete*, Bloomington: Fine Arts Department, Indiana University, 1966.

A portfolio of silkscreened posters (23 × 34 in.) of *Flowers in Concrete*, based on the typographical versions from 1966, was self-published by Solt in an edition of 40 in 1969.

Previous publications (1963–1978) include "White Rose" in *Poor. Old. Tired. Horse.*, no. 8, 1963; "Geranium" in *Labris* (Belgium), January 1964; "Lilac" in Labris, April 1964; "Wild Crab" in Labris, July 1964; "Lobelia" in *Labris*, October 1964; "Zinnia" in *Labris*, January 1965; "Forsythia" in *Labris*, July 1965; "Marigolds" and "Dogwood: Three Movements" in *Poetry*, March 1966; "Dogwood: Three Movements" in *Labris*, July 1966; "Forsythia," "Geranium," and "Dogwood: Three Movements" in *An Anthology of Concrete Poetry*, New York: Something Else Press/Stuttgart: Edition Hansjörg Mayer, 1967 (reprint, New York: Primary Information, 2013); "Forsythia" in *Artes Hispanicas/Hispanic Arts* 1, no. 3/4, 1968; "Forsythia" in *Concrete Poetry: A World View*, Bloomington: Hispanic Arts, Indiana University, 1968 (reprint, Bloomington: Indiana University Press, 1970); "White Rose" in "Vers un nouveau langage," *Approches* (Paris), no. 3, 1968; "White Rose" in "Poëzie in fusie," *Bladen voor de poëzie* (Lier), no. 6–8, 1968; "Forsythia" in *La Biennale di Venezia: mostra di poesia concreta, Poesia concreta: Indirizzi,*

concreti, visuali e fonetici (exhibition catalog), Venice: Stamperia di Venezia, 1969; "Lilac" in *Anthology of Concretism*, Chicago: Swallow Press, 1969; "Lobelia," "Wild Crab," Marigolds," and "Zinnia" in *Quickly Aging Here: Some Poets of the 1970s*, Garden City, NY: Anchor Books, 1969; "Forsythia" and "Wild Crab" in *Shake the Kaleidoscope: A New Anthology of Modern Poetry*, New York: Pocket Books, 1973; "Forsythia," "Wild Crab," and "Lilac" in *Speaking Pictures: A Gallery of Pictorial Poetry from the Sixteenth Century to the Present*, New York: Harmony Books, 1975; "Lilac" in *Sztuka i komputery* (Art and computers), Warsaw: Państwowe Wydawnictwo Wiedza Powszechna, 1976; and "Forsythia" in *La Biennale di Venezia 1978: Arti visive e architettura: Materializzazione del linguaggio* (exhibition catalog), Venice: La Biennale di Venezia, 1978 (reprint, Venice: La Biennale di Venezia, 2022).

Previous publications (1980–2022) include "Forsythia" and "Wild Crab" in *A Book of Women Poets from Antiquity to Now*, New York: Schocken Books, 1980; *Flowers in Concrete* in *Poiesis: Aspects of Contemporary Poetic Activity*, Edinburgh: Fruitmarket Gallery/London: Distributed Art Publishers, 1992; *Flowers in Concrete* in "Mary Ellen Solt: Toward a Theory of Concrete Poetry," special issue, *OEI* (Stockholm), no. 51, 2010; "White Rose" and "Zinnia" in *The Art of Typewriting*, London: Thames & Hudson, 2015; "Forsythia" in *Oral Interpretation*, 13th ed., London: Routledge, 2018; "Forsythia" in *Concrete Poetry: A 21st-Century Anthology*, London: Reaktion Books, 2021; "Forsythia" in *How to Read (and Write About) Poetry*, 2nd ed., Peterborough, ON: Broadview Press, 2021; "Forsythia," "Zinnia," "Geranium," "Lilac," "Wild Crab," and "Crab 2" in *Biennale Arte 2022: The Milk of Dreams* (exhibition catalog), Venice: La Biennale di Venezia/Milan: Silvana Editoriale, 2022; and "Geranium" in *A Something Else Reader*, New York: Primary Information, 2022.

Words and Spaces

Previous publications (1964–1978) include "USA Poem" in *Poor. Old. Tired. Horse.*, no. 12, 1964; "Moonshot Sonnet" in *Poor. Old. Tired. Horse.*, no. 14, 1965; "ZIGZAG" in *Labris*, July 1965; "Moonshot Sonnet" in *An Anthology of*

Concrete Poetry, New York: Something Else Press/Stuttgart: Edition Hansjörg Mayer, 1967 (reprint, New York: Primary Information, 2013); "Poem without Beginning or End" in Labris, July 1967; "Elegy for Three Astronauts" in Once Again, New York: New Directions, 1968; "Moonshot Sonnet" in Artes Hispanicas/Hispanic Arts 1, no. 3/4, 1968; "Moonshot Sonnet" in Concrete Poetry: A World View, Bloomington: Hispanic Arts, Indiana University, 1968 (reprint, Bloomington: Indiana University Press, 1970); "Elegy for Three Astronauts" and "Moonshot Sonnet" in Inside Outer Space: New Poems of the Space Age, New York: Doubleday, 1970; A Trilogy of Rain, Urbana, IL: Finial Press, 1970; "Time" in Earthjoy, Fort Wayne, IN: Fort Wayne School of Fine Arts Press, 1971; "A Trilogy of Rain" in This Book Is a Movie: An Exhibition of Language Art and Visual Poetry, New York: Dell, 1971; "ZIGZAG," "daughters," "leaf/fall," and "roads" in Visible Language 6, no. 2, Spring 1972; "For Lorine Niedecker (waterfall)" in Epitaphs for Lorine, Penland, NC: Jargon Society, 1973; "(Watergate) Transcript for Uncle Sam" in White Arms Magazine, no. 1, April 1974; "Prisons" in West Coast Poetry Review, Summer 1974; "Gold Pin for Gertrude Stein" in 590A or: The uncool season is here, Easter 1975; "ZIGZAG" in Arti visive. Poesia visiva. / Visual Poetry by Women, Rome: Studio d'Arte Contemporanea, 1976; and "Time" [broadside], Pittsburgh, PA: Poetry on the Buses/Carnegie Mellon University Press, 1978.

Previous publications (1980–2022) include "Moonshot Sonnet" and "Rain Down" (from "A Trilogy of Rain") in A Book of Women Poets from Antiquity to Now, New York: Schocken Books, 1980; "Gold Pin for Gertrude Stein" in Redstart Plus Series, 1988; "Snowflakes" in American Poetry Anthology 8, no. 1, 1988; "Moonshot Sonnet" in Disappearing Through the Skylight: Culture and Technology in the Twentieth Century, New York: Viking, 1989; "Widow" (from "Elegy for Three Astronauts"), "A Trilogy of Rain," "ZIGZAG," "Moonshot Sonnet," and "For Lorine Niedecker (waterfall)" in "Mary Ellen Solt: Toward a Theory of Concrete Poetry," special issue, OEI, no. 51, 2010; "Rain Down" (from "A Trilogy of Rain") in The Art of Typewriting, London: Thames & Hudson, 2015; A Gold Pin for Gertrude Stein, Pittenweem, Scotland: Moschatel Press, 2018; "Elegy for Three Astronauts" and "Moonshot Sonnet" in Beyond Earth's Edge: The Poetry of Spaceflight, Tucson: University of Arizona Press, 2020; "Moonshot Sonnet" in Concrete Poetry: A 21st-Century Anthology, London: Reaktion Books, 2021; and "Moonshot Sonnet" in The American Sonnet: An Anthology of Poems and Essays, Iowa City: University of Iowa Press, 2022.

The Peoplemover 1968:
A Demonstration Poem

The original posters for The Peoplemover 1968: A Demonstration Poem are in the Mary Ellen Solt archive at the Lilly Library, Indiana University, Bloomington.

The Peoplemover 1968: A Demonstration Poem [silkscreen poster portfolio, 16 × 22 in.], Urbana, IL: Finial Press, 1970.

Versions of the posters and/or the performance text have been reproduced in Open Poetry: Four Anthologies of Expanded Poems, New York: Simon and Schuster, 1973 [posters]; The Peoplemover 1968: A Demonstration Poem, Reno, NV: West Coast Poetry Review, 1978 [posters and performance text]; "Mary Ellen Solt: Toward a Theory of Concrete Poetry," special issue, OEI, no. 51, 2010 [posters and performance text]; Wir Spielen (We Play) 2013: The Peoplemover 1968, A Demonstration Poem, Berlin: nGbK, neue Gesellschaft für bildende Kunst, 2013 [performance text]; and "ResurrACTIONCity" [poster] in The Art of Typewriting, London: Thames & Hudson, 2015.

Marriage: A Code Poem

Marriage: A Code Poem was initially published as Marriage, Urbana, IL: Finial Press, 1976.

Subsequent publications are found in A Book of Women Poets from Antiquity to Now, New York: Schocken Books, 1980; "Mary Ellen Solt: Toward a Theory of Concrete Poetry," special issue, OEI, no. 51, 2010; and Women in Concrete Poetry: 1959–1979, New York: Primary Information, 2020.

Letter to the Editor (later poems)

None of the poems in this section have been previously published.

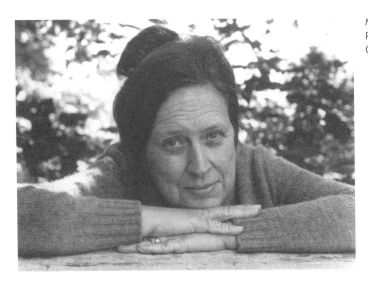

Mary Ellen Solt, c. 1980.
Photograph by
Catherine Solt.

Mary Ellen Solt
July 8, 1920–June 21, 2007

Born in Gilmore City, Iowa, poet Mary Ellen Solt (née Bottom) was the first child and oldest daughter of Arthur Bottom, a Methodist minister from Yorkshire, England, and Edith Bottom (née Littell), an Iowa schoolteacher, who together raised four children in all. Solt was educated at Iowa State Teachers College (now the University of Northern Iowa), where she studied piano, her first and longtime passion, with Louis Crowder before earning a bachelor's degree in English literature in 1941. Directly out of college, Solt embarked on her first career as a high school English teacher. She went on to earn a master's degree in English from the University of Iowa in 1948; her thesis was titled *An Historical Study of Shakespeare's 3 Henry VI*. In 1946, while in school in Iowa City, she married fellow graduate student Leo F. Solt, who had recently returned home from service in the Pacific during World War II as a naval officer. After receiving their degrees, the couple moved to New York City in 1948, where Leo pursued doctoral studies in history at Columbia University. Solt taught at the Bentley School and studied poetry at Columbia with Leonora Speyer and at the

Poetry Center with John Malcolm Brinnin and Kimon Friar, among others. It was in New York that Solt developed a keen interest in the poetry of William Carlos Williams; she eventually reached out to Williams, and he became her mentor. Soon, he and his wife, Florence, became good friends with the Solts.

The Solts had two daughters in the mid-1950s, first Catherine and then Susan, while Leo was a professor of history at the University of Massachusetts, Amherst. Soon after Susan's birth, the family moved to Bloomington, Indiana, where Leo was offered a more desirable appointment at Indiana University as a professor of early modern English history. In 1970, when the girls were young teenagers, and after a prominent career as an independent poet and scholar, Solt became a professor of comparative literature at IU, a position she held until her retirement in 1991.

Mary Ellen Solt began writing concrete poetry after meeting Ian Hamilton Finlay in Edinburgh, Scotland, in 1962. Finlay was the first to publish Solt's early concrete poems, and their deep friendship lasted throughout their lives. Solt became a leader in the concrete poetry movement, editing the highly influential anthology *Concrete Poetry: A World View* after Willis Barnstone

commissioned her to guest edit an issue of the journal *Artes Hispanicas/Hispanic Arts* devoted to concrete poetry in 1968; this issue was published in book form in 1968 and reprinted in 1970. Solt is the author of the poetry collections *Flowers in Concrete* (1966), *Marriage* (1976), and *The Peoplemover 1968: A Demonstration Poem* (1978), as well as the poetry pamphlet *A Trilogy of Rain* (1970). *Flowers in Concrete: Portfolio Edition* (1969) was created as a set of silkscreened poster poems for exhibition, and *The Peoplemover 1968* (1970) was published by the Finial Press as a set of silkscreened poster poems, also for exhibition.

Mary Ellen Solt's concrete poetry has been exhibited worldwide, most recently in 2022 at the 59th Venice Biennale, *The Milk of Dreams (Il latte dei sogni)*, curated by Cecilia Alemani; and in 2017 as part of *Concrete Poetry: Words and Sounds in Graphic Space*, curated by Nancy Perloff at the Getty Center in Los Angeles. Solt's concrete poetry was also exhibited at the Venice Biennale earlier in her career (1968 and 1978), and at the Jewish Museum in New York City (1970) and the Stedelijk Museum in Amsterdam (1970).

Mary Ellen Solt was first recognized professionally for her critical writing on William Carlos Williams. Her essay "The American Idiom," published in the *William Carlos Williams Review* (1983), documents Williams's July 1960 visit to Bloomington, Indiana, where Solt delivered a public lecture to the IU School of Letters on his poetry. It was a memorable enough event that Williams memorialized the raucous debate that erupted in a poem entitled "He Has Beaten about the Bush Long Enough." From 1983 to 1985, Solt served as the president of the William Carlos Williams Society; also in 1985, she edited *Dear Ez: Letters from William Carlos Williams to Ezra Pound*. During the 1987–88 academic year, Solt received a fellowship from the National Endowment for the Humanities to support her scholarship on William Carlos Williams. In 1993, after her retirement from teaching, the *William Carlos Williams Review* published "A Special Double Issue: Essays in Honor of Mary Ellen Solt and Hugh Kenner."

A special issue of *OEI* magazine published in 2010, titled "Mary Ellen Solt:

Toward a Theory of Concrete Poetry," edited by Antonio Sergio Bessa and with an introduction by Marjorie Perloff, features Solt's collected critical essays on a variety of topics, including Williams, semiotics, the Objectivist poets, the concrete poets, and the international concrete poetry movement. Solt's concrete poems, most notably "Forsythia" and "Moonshot Sonnet," have appeared in countless anthologies over the years, most recently *Women in Concrete Poetry: 1959–1979* (2020) and *Concrete Poetry: A 21st-Century Anthology* (2021).

Mary Ellen Solt was professor emerita of comparative literature at Indiana University, Bloomington, at the time of her death. She directed the Polish Studies Center at IU from 1977 to 1984 and taught at the University of Warsaw for the 1976–77 academic year. In recognition of her distinguished service to cultural and educational exchange, Solt received the Grand Cross of the Order of Merit of the Republic of Poland for improving relations between nations.

In 1996, following Leo's death, Solt moved to Santa Clarita, California, to live with her daughter Susan. Her papers and concrete poetry collection are archived at the Lilly Library, Indiana University, Bloomington, and at the Getty Research Institute.

Susan Solt

Susan Solt is currently a distinguished professor of theater arts and the former dean of the Arts Division, University of California, Santa Cruz. She was also a visiting researcher in the Department of African American Studies at UCLA for the 2023–24 academic year, and at the UC Santa Barbara Interdisciplinary Humanities Center from 2020 to 2022. For twenty years, Solt was on the faculty at California Institute of the Arts, where she served as dean of the School of Theater and was also founding artistic director/producer of the experimental Center for New Theater (renamed the Center for New Performance in 2006). Her signature work as a producer of theater is a site-specific, all-female, multicultural production of Shakespeare's *King Lear* that played the Frictions Festival in Dijon, France, in 2003. As producer, Solt received an NAACP Theatre Image Award for *King Lear*.

As a feature film producer in New York City in the 1980s, Solt worked exclusively with Academy Award–winning director Alan J. Pakula. She began her film career as the artistic coordinator on *Sophie's Choice* (1982), and served as Meryl Streep's Polish dialect coach, having learned the language as a Fulbright-Hays Fellow while studying with Polish avant-garde theater director Jerzy Grotowski. After her tenure with Pakula, Solt was senior vice president of production for Miramax Films, working with such artists as Alexander Payne and David O. Russell. As an independent producer for Warner Bros., she produced the award-winning feature films *Presumed Innocent* (1990) and *Doc Hollywood* (1991), among others.

Solt matriculated Smith College and received her AB from Indiana University, Bloomington. She earned an MFA from the Yale School of Drama, an MA in African American studies from UCLA, and a PhD in history from UCLA. She is the author of a chapter in the publication *Lessons of the Hour: Frederick Douglass*, which accompanied the 2021 exhibition of the same name by British artist and filmmaker Isaac Julien.

Susan Solt is the younger of Mary Ellen Solt's two daughters and is the literary executor of her mother's estate.

The Collected Poems of Mary Ellen Solt
© 2024 The Estate of Mary Ellen Solt
and Primary Information

ISBN: 979-8-9885736-9-2

Foreword © 2024 Aram Saroyan
Afterword © 2024 Susan Solt

Photograph of *The Peoplemover* performance
courtesy of Timothy Mayer.

Photographs of Leo and Mary Ellen Solt
courtesy of the Estate of Mary Ellen Solt.

Photograph of William Carlos Williams with
Leo, Mary Ellen, and Susan Solt from the
William Carlos Williams Papers and courtesy
of the Yale Collection of American Literature,
Beinecke Rare Book and Manuscript Library,
Yale University.

"He Has Beaten about the Bush Long Enough"
by William Carlos Williams, from *The
Collected Poems: Volume II, 1939–1962*, © 1962
by William Carlos Williams. Reprinted by
permission of New Directions Publishing Corp.
and Carcanet Press.

Photograph of Ian Hamilton Finlay courtesy of
the Estate of Mary Ellen Solt.

Letter from William Carlos Williams to Mary
Ellen Solt used with the permission of the
William Carlos Williams MD Estate in care of
the Jean V. Naggar Literary Agency Inc.
Image of the letter courtesy of the Lilly Library,
Indiana University, Bloomington.

Photograph of Mary Ellen Solt courtesy of the
Estate of Mary Ellen Solt.

Editor: Susan Solt
Managing Editor: Ryan Haley
Designer: Bryce Wilner
Copy Editor: Allison Dubinsky

Primary Information
232 Third Street, #A113
The Old American Can Factory
Brooklyn, NY 11215
www.primaryinformation.org

Printed by Grafiche Veneziane in Venice, Italy.

Primary Information would like to thank Katy
Darr and Moira Fitzgerald of the Beinecke
Rare Book and Manuscript Library, Yale
University; Erika Dowell and Isabel Planton of
the Lilly Library, Indiana University, Blooming-
ton; and Rebecca Federman of the New York
Public Library for their research assistance.
Additional thanks go to Timothy Mayer,
Aram Saroyan, Catherine Solt, and Dr. Erdmute
Wenzel White.

This book is made possible, in part, by the
generous support of Joanna Miller.

Primary Information is a 501(c)(3) non-profit
organization that receives generous support
through grants from the Michael Asher
Foundation, Galerie Buchholz, the Patrick and
Aimee Butler Family Foundation, the Cowles
Charitable Trust, Empty Gallery, the Ford
Foundation, the Fox Aarons Foundation, the
Helen Frankenthaler Foundation, Further-
more: a program of the J. M. Kaplan Fund, the
Graham Foundation for Advanced Studies
in the Fine Arts, Greene Naftali, the Greenwich
Collection Ltd., the John W. and Clara C.
Higgins Foundation, Metabolic Studio, the
New York City Department of Cultural
Affairs in partnership with the City Council,
the New York State Council on the Arts with
the support of the Office of the Governor and
the New York State Legislature, the Orbit
Fund, the Robert Rauschenberg Foundation,
the Stichting Egress Foundation, VIA Art Fund,
the Jacques Louis Vidal Charitable Fund,
the Andy Warhol Foundation for the Visual
Arts, the Wilhelm Family Foundation, and
individuals worldwide. Primary Information
receives support from the Arison Arts
Foundation, the Willem de Kooning Founda-
tion, the Marian Goodman Foundation,
the Henry Luce Foundation, and the
Teiger Foundation through the Coalition of
Small Arts NYC.